CONVERSATIONS

CONVERSATIONS

*Up Close and Personal with Icons of Fashion,
Interior Design, and Art*

BLUE CARREON

Skyhorse Publishing

Skyhorse Publishing books may be purchased in bulk at special discounts for sales promotion, corporate gifts, fund-raising, or educational purposes. Special editions can also be created to specifications. For details, contact the Special Sales Department, Skyhorse Publishing, 307 West 36th Street, 11th Floor, New York, NY 10018 or info@skyhorsepublishing.com.

Skyhorse® and Skyhorse Publishing® are registered trademarks of Skyhorse Publishing, Inc.®, a Delaware corporation.

Visit our website at www.skyhorsepublishing.com.

10 9 8 7 6 5 4 3 2 1

Library of Congress Cataloging-in-Publication
Data is available on file.

Cover design by Rain Saukas

Print ISBN: 978-1-62914-547-1
Ebook ISBN: 978-1-62914-909-7

Printed in China

DEDICATION

For Bruce

FOREWORD

"Conversation should touch everything, but should concentrate on nothing."

—According to one of the world's late great conversationalists, Oscar Wilde

I admit to being completely devoted to Blue's *Huffington Post* "Conversations" series, hooked from the very first published piece. Yes, the insights are inspiring, informative, and sometimes amusing, but what's more is that each interview feels like an excerpt from the unpublished memoirs of the most stylish and creative minds.

When Blue first asked me to participate in the column, I felt thrilled, and honored and a bit unworthy to join such prestigious creators from the worlds of interior and fashion design, art, photography, and literature. Nevertheless, I had a ball with the questions which were so seemingly simple, yet fun to answer and unquestionably insightful. I, of course, had definite opinions for every question, from what "women should always" do (handwritten notes!) to what "men should never" do, (never go more than a week without calling your mother!), answered from as much the perspective of a mother of four boys, as that of a designer. I love that the questions intersected all corners of life and what's more, I love reading everyone else's responses.

Blue and I first met in Hong Kong ten years ago, through an editorial assignment when Blue was with the *Hong Kong Tatler*. He has remained a dear friend, and in addition, I am his great admirer. His talents are many and diverse, and his innate sense of style permeates everything he touches — from his writing, to his interior design. Beyond this, I also adore and respect his soft-spoken charm, the gracious way he leads his life, and his quest for beauty in everything he does. Along with being a great journalist, perhaps it is Blue's kind and disarming nature that allows such interesting, and even revealing answers, to reach the surface . . .

Perhaps the best conversations are the ones that are overheard, or it seems that way. I remember the very first interview with Ines de la Fressange, and her cryptic but evocative answer with regards to her mother—it still has me wondering. And how reflective the responses are of each designer's personal style—that Herve Van Der Straeten believes "Nature will have the last word," while John Varvatos says, in the end, "It's only rock and roll, and I like it!"

Jean Cocteau wrote, "style is a simple way of saying complicated things," and perhaps Blue knows this best. Revealed, via a menu of simple questions, are inspirations, and revelations—all delivered plain or spicy, and always with more than a dash of chic.

—Fiona Kotur

INTRODUCTION

I've always been drawn to creative people and fascinated by the way they work and live. What I love most about reading Blue's profiles is that they allow you to peer into the lives of artistic people that I've come to know and respect. It's fascinating to get a glimpse into the minds of such stylish people and to learn something unique about them that we would never uncover in a different forum. Answering his questions myself was an amusing and thought-provoking experience. It made me stop and think about the way I live and how I view my surroundings. I especially admire the way that Blue is interested in imaginative people across the board...often melding the fashion and interior design industry into one. I have always thought that we are all in the world of aesthetics and style and should collaborate more often. And who better to talk about all types of style than Blue himself; a mere glimpse at his Instagram and ever-changing fashion is the quickest way for me to realize how poorly I dress!

I hope you enjoy these profiles just as much as I have.

— Nathan Turner

ALESSANDRO SARTORI
Fashion Designer-Berluti

When I wake up... I look outside—wherever I am—but I need to look outside.

Before I go to bed... I listen to a few songs of my favorite soundtrack.

A well-dressed man... should wear a dark fitted navy three-piece bespoke suit with Berluti Leonard Boots in Saint Emilion color, a white shirt and a blue solid tie.

Women should always... do things with elegance.

Men should never... wear the wrong shoes.

The best thing that's been said about me... a few years ago one day after a show, a journalist wrote that I was the best new tailor around! That meant a lot to me.

The biggest misconception about me... a few years ago one day after a show another journalist wrote that were there a lot of beautiful men with nude chests in my show, but the show was actually all about men with shirts and ties!

If I weren't doing what I'm doing today... I would have tried to have my own little tailor's atelier.

My legacy... I am still working on it.

A great idea... is to spend time making intelligent things.

Botox is... I do not get it.

My mother... is my muse.

The soundtrack of my life... *Heaven* from Talking Heads.

The future... A lot of new creative ideas to put in practice.

Happiness... is to make interesting new things for the first time. Do you remember when you did something interesting and completely new for the first time? I love the emotion of that feeling.

There's a time and place for... wearing the best tuxedo ever.

There is too much... bad styling around.

In the end... it is not about the brand you wear, it is about the style you have.

Happiness... is to make interesting new things for the first time. Do you remember when you did something interesting and completely new for the first time? I love the emotion of that feeling.

ALEXA HAMPTON
Interior Designer

When I wake up... I check to see which of my children has snuck into my bed overnight and then I go in for a cuddle. Nothing is better than a warm, sleepy child.

Before I go to bed... I put on my Revitalash, set my alarm on my Blackberry, and make sure all my devices are charging. Then I kiss my wonderful husband goodnight.

A well-dressed man/woman... wears their clothes and doesn't let their clothes wear them.

Women should always... refuse to let others dictate who they need to be.

Men should never... try to tell a woman who she needs to be (or wear short-sleeved button downs).

The best thing that's been said about me... when asked in class to name his hero, my son Michael said "My mommy because she loves me and is always nice to me." However, I think he must not have realized he could say anyone. If he had, he likely would have named the soccer player Lionel Messi.

The biggest misconception about me... is that I am a Park Avenue Princess. If only!

If I weren't doing what I'm doing today... I would do it tomorrow. (Or I would be an unsuccessful artist.)

My legacy... is my family. I hope I don't mess up my children too horribly. I also hope some of the products I have designed will stand the test of time. Currently, I like to think of myself as Queen of the Flush Mount. (Has a sobriquet ever been quite so glamorous?)

A great idea... is something that really makes sense and serves a purpose, no matter how big or small that purpose is.

Botox is... pretty fabulous.

My mother... is loving, smart, beautiful, reads everything, and has an amazing vocabulary. Not too shabby.

The soundtrack of my life... is Stevie Wonder, without question.

The future... is exciting and filled with endless potential.

Happiness... is my children, my husband, my friends, cheese on a baguette, completing and installing a beautiful project, reading a great book, *Star Wars* episodes 4, 5, and 6, red wine, sleeping late, and Souvenirs of the Grand Tour

There's a time and place for... kindness and civility, and that time is now.

There is too much... intolerance and small mindedness. And, while we're at it, rudeness and bad grammar.

In the end... we all have to live our lives. Why not do that while being kind and having fun? Optimism is a wonderful thing.

The biggest misconception about me... is that I am a Park Avenue Princess. If only!

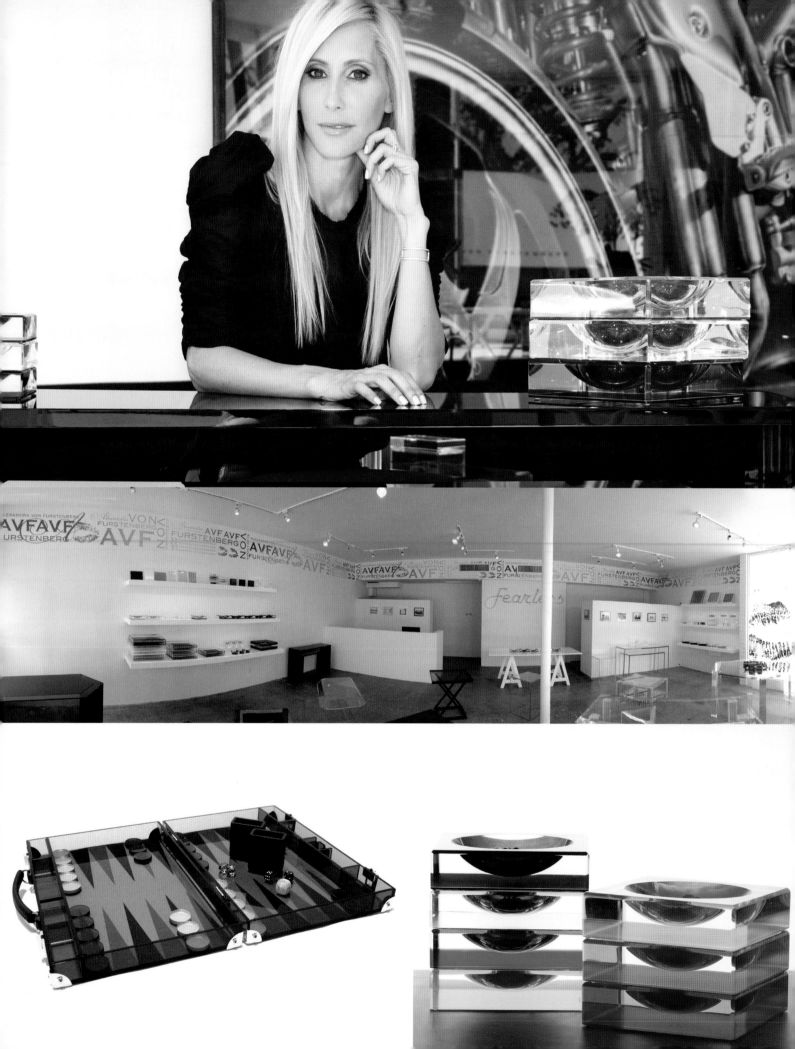

ALEXANDRA VON FURSTENBERG
Furniture Designer

When I wake up...I give thanks.
Before I go to bed...I take a bath.
A well-dressed man...is hypnotic.
Women should always...be kind.
Men should never...be rude.
The best thing that's been said about me...I am loyal and kind.
The biggest misconception about me...is that I am mean.
If I weren't doing what I'm doing today...I'd be a life coach.
My legacy...is how I raised my children.
A great idea...is energizing.

Botox is...good in moderation.
My mother...has great taste.
The soundtrack of my life...is always different, but disco always does the trick.
The future...holds so much!
Happiness...is living every second with love, grace, and gratitude.
There's a time and place for...eating with your fingers.
There is too much...fear and hatred in this world.
In the end...love is all that matters.

The soundtrack of my life...is always different, but disco always does the trick.

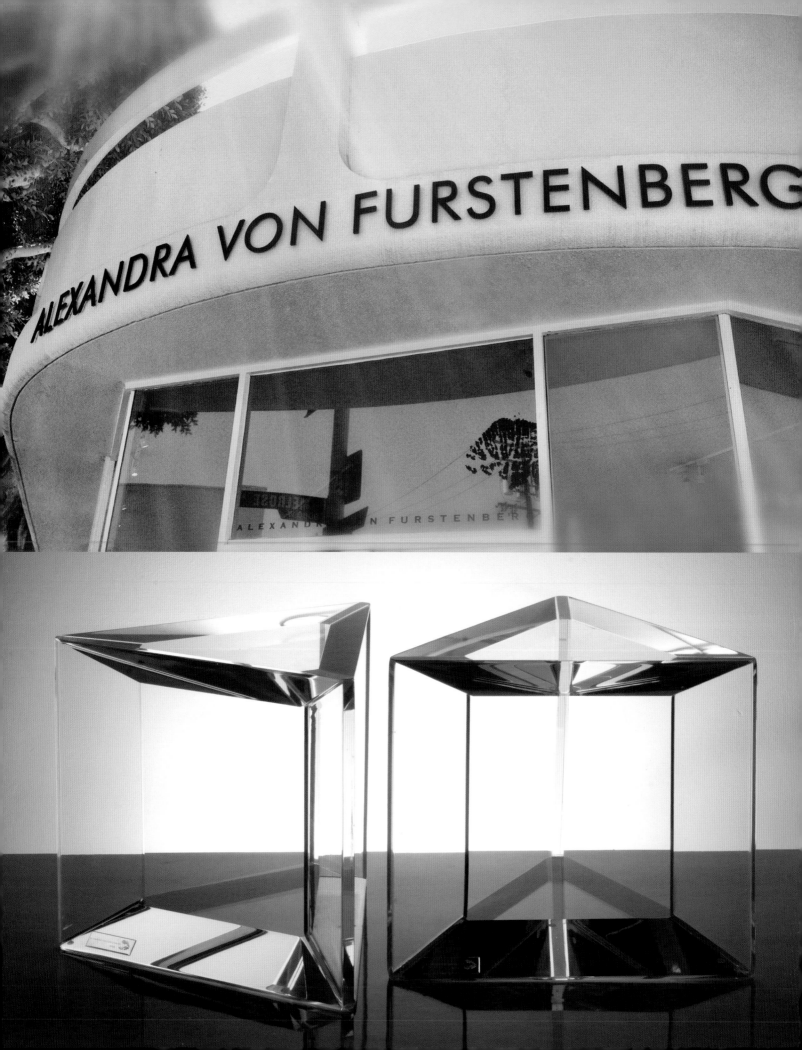

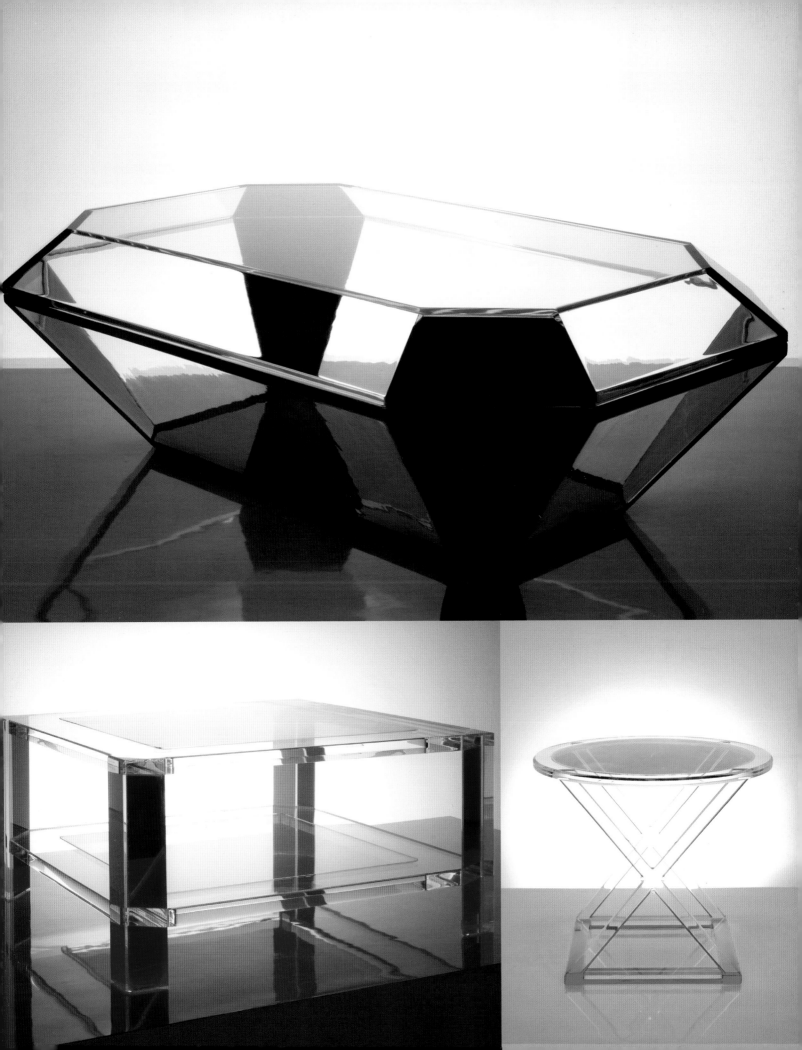

AMANDA NISBET
Interior Designer

When I wake up... I must have lots of strong coffee.

Before I go to bed... I read my horoscope for the next day.

A well-dressed man/woman... is imperative.

Women should always... empower each other.

Men should never... be unkind to a woman.

The best thing that's been said about me... is that I have an infectious exuberant energy.

The biggest misconception about me... is that I'm always "on." Truly I'm like a puppy dog, I love to play and have fun, but then I need a long nap to recharge and play again.

If I weren't doing what I'm doing today... I'd be a backup singer for The Rolling Stones.

My legacy... is my children.

A great idea... would be for one not to judge.

Botox is... When it is good it is very, very good and when it is bad it is horrid.

My mother... is my style icon.

The soundtrack of my life... is "I've Got So Much Love to Give."

The future... is always full of promise.

Happiness... is being loved and with the ones you love.

There's a time and place for... indulgence.

There is too much... hurt, anger, and judgment—and not enough compassion, forgiveness, and love.

In the end... you are responsible for the energy you bring into the room and into your life.

There is too much... hurt, anger, and judgment, and not enough compassion, forgiveness, and love.

ASHLEY HICKS
Architect and Interior Designer

When I wake up... I check the sky.

Before I go to bed... I read a few pages of Trollope or Franzen. OK, actually that's in bed.

A well-dressed man/woman... is something to enjoy. Not, I must admit, something that I've ever managed to be.

Women should always... maintain the mystery.

Men should never... attempt to do the same.

The best thing that's been said about me... "YOU ALWAYS RUIN EVERYTHING." (From my daughters, constantly, joking, I hope!)

The biggest misconception about me... is that I'm David Hicks's daughter, but then Ashley is more often a girl's name. Not quite Johnny Cash's 'A Boy Named Sue,' but almost.

If I weren't doing what I'm doing today... I'd be lost.

My legacy... will be some rather chaotic rooms that my girls will have to dismantle.

A great idea... comes without conscious thought. Then comes the hard work to make it real.

Botox is... poison, isn't it?

My mother... likes to come over in the evening and watch movies in my seaweed-green cinema.

The soundtrack of my life... features Lykke Li, Bessie Smith, Mina and Alison Mosshart.

The future... is what I drew as a child. Now it's less clear.

Happiness... is being with someone I love. Corny, but true.

There's a time and place for... pretty much everything.

There is too much... educational content in museums. They should be passive places of discovery, not active ones of teaching.

In the end... I'll be buried next to my parents in an Oxfordshire churchyard. They have a stumpy obelisk of my design. One of my girls will have to think of something for me.

The future… is what I drew as a child. Now it's less clear.

BARBARA BARRY
Interior Designer

When I wake up... I look at the light—always there and magical!

Before I go to bed... I listen to my favorite podcasts, *On Being* and *Radio Lab*.

A well-dressed woman... is defined by just a few inches or tucks.

Women should always... bring all they have to the table.

Men should never... wear short-sleeved shirts!

The best thing that's been said about me... is that I have made a difference in my industry.

The biggest misconception about me... is that I am a snob.

If I weren't doing what I'm doing today... I would be studying landscape and making gardens.

My legacy... is an authentic American point of view... furthered along.

A great idea... is the beginning of something wonderful and what makes life worth living.

Botox is... the stifler of true character.

My mother... was my most vibrant mentor. She taught me that money has nothing to do with style and everything to do with confidence.

The soundtrack of my life... is Louis Armstrong singing "What a Wonderful World."

The future... has arrived!

Happiness... is found in the little moments, one little moment to the next.

There's a time and place for... just "being" and not "doing."

There is too much... violence in everything... Why?

In the end... I hope we can all find the simple beauty that surrounds us daily and stop to take it in.

If I weren't doing what I'm doing today . . . I would be studying landscape and making gardens.

BARBARA TFANK
Fashion Designer

When I wake up... I wake up very early to meditate then go the gym.

Before I go to bed... I watch an inspiring film like Visconti's *The Leopard*, Max Ophuls' *The Earrings of Madame D,* Jean Renoir's *The River*...something visually stunning that I can still see when I close my eyes.

A well-dressed woman... looks comfortable in her clothes.

Women should always... wear lipstick and chic sunglasses.

Men should never... wear too much cologne.

The best thing that's been said about me... I could never design anything vulgar.

The biggest misconception about me... is where I'm from. I'm from New York and I split my time between New York and Los Angeles.

If I weren't doing what I'm doing today... I might work in film again.

My legacy... beautiful timeless clothes that you will not look ridiculous wearing in ten years.

A great idea... let it be.

Botox is... fine in moderation.

My mother... is a true clotheshorse.

The soundtrack of my life... the nocturnes of John Field.

The future... is exciting and hopeful.

Happiness... innovation & discovery.

There's a time and place for... reflection.

There is too much... fear.

In the end... it's all about love.

Women should always... wear lipstick and chic sunglasses.

BIBHU MOHAPATRA
Fashion Designer

When I wake up... I need light.

Before I go to bed... I read.

A well-dressed woman... is always inspiring.

Women should always... feel equal or better than men.

Men should never... disagree with women on the above.

The best thing that's been said about me... is that I am real.

The biggest misconception about me... is yet to come.

If I weren't doing what I'm doing today... I would be doing it tomorrow and the day after.

My legacy... is my craft.

A great idea... is season-less.

Botox is... not a magic potion.

My mother... is the one who gave me everything.

The soundtrack of my life... is being written.

The future... is momentary.

Happiness... is not a birthright.

There's a time and place for... some things.

There is too much... mediocrity.

In the end... it all stays behind and becomes history.

In the end... it all stays behind and becomes history.

BRUNO FRISONI
Designer—Roger Vivier

When I wake up...already?! Quick, a glass of water!

Before I go to bed...I look at art books while listening to music, or a last drink with friends.

A well-dressed woman...is effortless and in communion with herself.

Men should never...wear white socks.

The best thing that's been said about me...I'm fun.

The biggest misconception about me...that I am a shoe designer.

If I were not doing what I am doing today...I would be doing something similar, related to design or art of some sort, maybe an illustrator or a cartoonist.

My legacy...is something between fun, humor, and a chic sense of style.

A great idea...is something that is simple yet surprising and so good that it stays long enough to become a classic.

Botox is...aging!

My mother...was a great cook and a lovely looking woman. She was very feminine, simple but with a great sense of style. The typical fifties Italian great look, like Sophia Loren.

The soundtrack of my life...classical music, electronic and Lucio Battisti, a favorite.

The future is...shorter and shorter. That's why I live every day with great pleasure, full of appetite and I never think of tomorrow. Every day is a gift.

Happiness...you have to work at it, it does not come by itself.

There's a time and place...friends, love, and everybody you care about.

There is too much...hate, war, politics, idiots, poverty, and fashion!

In the end...everything has to be lived. *C'est la vie*...and I'll say thanks...I cannot complain!

A great idea...is something that is simple yet surprising and so good that it stays long enough to become a classic.

BUNNY WILLIAMS
Interior Designer

When I wake up... The morning is my time. I treat my bed like a sitting room or office in the morning. I spend about two hours in bed doing stuff before I go to work—I spread out my newspapers and books and magazines, make phone calls, watch the news, and have breakfast on a tray.

Before I go to bed... My husband says I have two speeds—race and collapse—I lie down, and I'm out!

A well-dressed man/woman... knows how to dress for who they are, and doesn't need to follow the latest trends.

Women should always... have a Rose (my hairdresser!).

Men should never... leave home without a shoe shine.

The best thing that's been said about me... I'm not afraid of having strong opinions and a strong drink every now and then.

The biggest misconception about me... is that I'm unapproachable. I'm from a southern, eccentric, horsy family and I'm pretty down-to-earth.

If I weren't doing what I'm doing today... I would probably have a small nursery and also build a space somewhere in my house where I could take in abandoned dogs and try to find homes for them.

My legacy... When I first started decorating, I knew I wanted to go work for Albert Hadley and Sister Parish. I owe so much to both of them. Mentoring young designers is something I feel is so important. I hope to pass on my design training to the next generation.

A great idea... isn't great unless you act on it.

Botox is... whatever makes you feel better.

My mother... always loved to entertain, so with her tutelage, it comes naturally to me.

The soundtrack of my life... *Bunny's Cuttin' A Rug* CD that my office made for me—it's got a little ABBA, Amy Winehouse, Bonnie Raitt and more!

The future... comes whether you're ready or not, so enjoy every moment.

Happiness... a late night swim in my pool in the Dominican Republic.

There's a time and place for... work...and more work. I work on paper, on a computer, on foot, and in every kind of weather! I always have a note pad and a camera so I can jot down something important or snap a photo.

There is too much... time spent on the computer rather than firsthand experiences.

In the end... It's been a wild and wonderful ride!

My legacy... Mentoring young designers is something I feel is so important. I hope to pass on my design training to the next generation.

CHARLOTTE MOSS
Interior Designer

When I wake up... I fix some coffee, check my iPad, then read a book for an hour.

Before I go to bed... I fix a chamomile tea, do my skin/face regimen, then sneak a peek at the iPad.

A well-dressed man... is always a refreshing sight.

Women should always... wear a smile and great lingerie!

Men should never... get dressed without looking in the mirror.

The best thing that's been said about me... is that I am generous and funny.

The biggest misconception about me... if they have one then they don't know me...I am pretty straight and direct.

If I weren't doing what I'm doing today... I would channel Russell Page and become a garden designer, or maybe Patsy Cline and sing country.

My legacy... a life that had a positive impact on others having created a little more beauty in the world.

A great idea... tell me!! I am always up for one. How about bringing back *House & Garden* or *Vogue Decoration*? We miss them terribly.

Botox is... a choice you make.

My mother... made home the center of our world. She is why I am doing what I am doing.

The soundtrack of my life... my backyard in East Hampton—birds, the ocean, tree frogs, and a crackling fire...soporific!

The future... is right now and made even better when you embrace that thought.

Happiness... is self-confidence. When you feel good about you, you're happy with everything and everybody.

There's a time and place for... most things! Manners tell all!

There is too much... time being spent in front of screens—missing life and being unaware.

In the end... not ready for that one. Too busy working on now.

My legacy… a life that had a positive impact on others having created a little more beauty in the world.

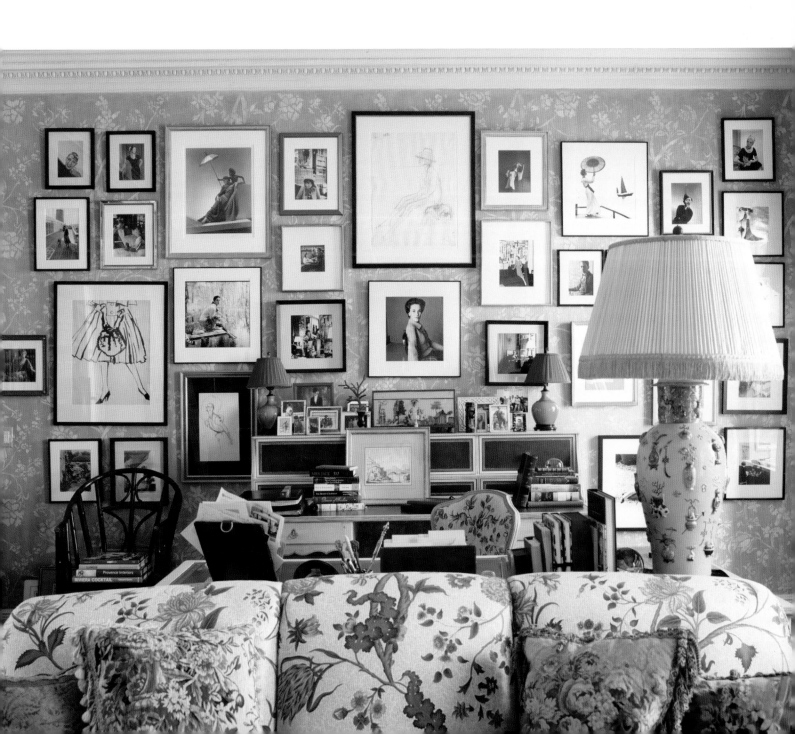

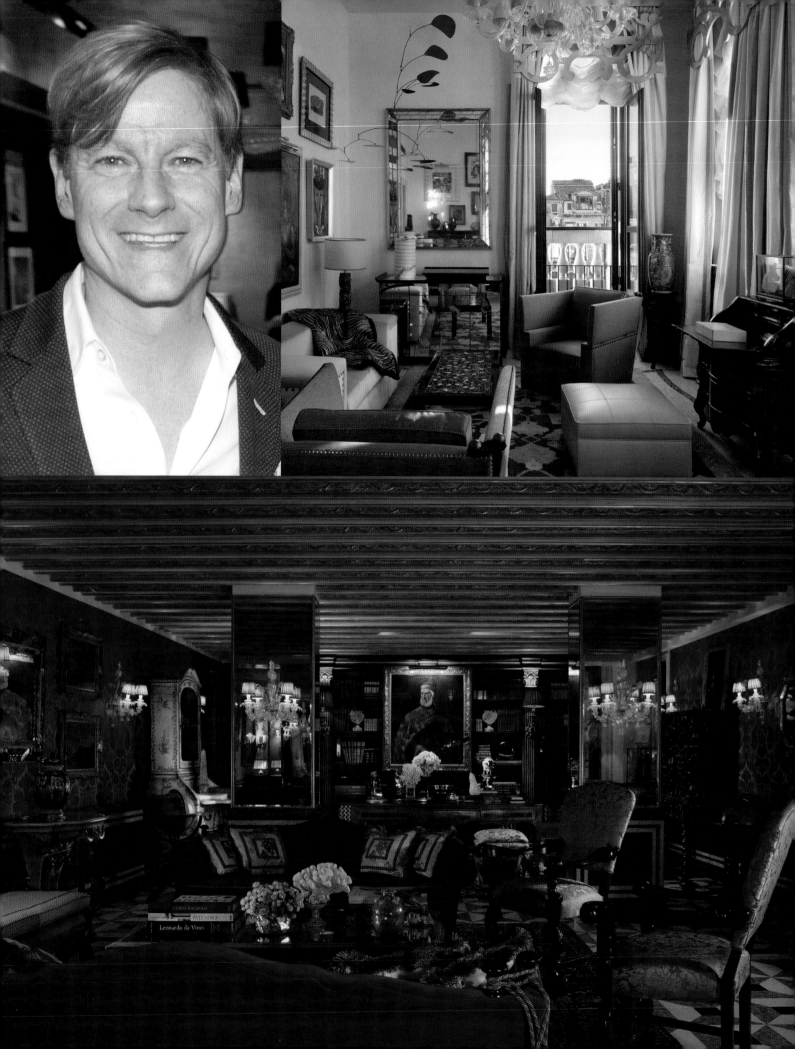

CHUCK CHEWNING
Interior Designer

When I wake up... I open the curtains and make up my bed so the room is beautiful first thing before I dress.

Before I go to bed... I always read a historical biography of someone who had an impressionable life.

A well-dressed man... does not have to rely on labels. Someone who is self-assured and knows who he is.

Women should always... underestimate men.

Men should never... underestimate women.

The best thing that's been said about me... I'm a generous friend.

The biggest misconception about me... one of my favorite things: that people think I'm younger than I really am—thanks to my good genes!

If I weren't doing what I'm doing today... I would be an architectural historian or concert pianist.

My legacy... is to be remembered for always giving and sharing all the wonderful things of my life with others.

A great idea... Savannah College of Art & Design, the groundbreaking university of creative careers!

Botox is... not for me, but it's nice to know it's there if I ever decide to take that route!

My mother... has always been one of my biggest supporters and at 83 she is still one of the most stylish ladies in Atlanta.

The soundtrack of my life... I began playing the piano when I was five and for me it would be performing Bach, Chopin, Gershwin, or Sondheim.

The future... can be an illusion or a reality—it is your destiny to navigate.

Happiness... the courtyard of my historic house in Savannah on a beautiful evening with those I love.

There's a time and place for... everything. And if not, then make it so!

There is too much... Kardashians.

In the end... nothing is really important except grounded family and dear friends.

The soundtrack of my life... I began playing the piano when I was five and for me it would be performing Bach, Chopin, Gershwin, or Sondheim.

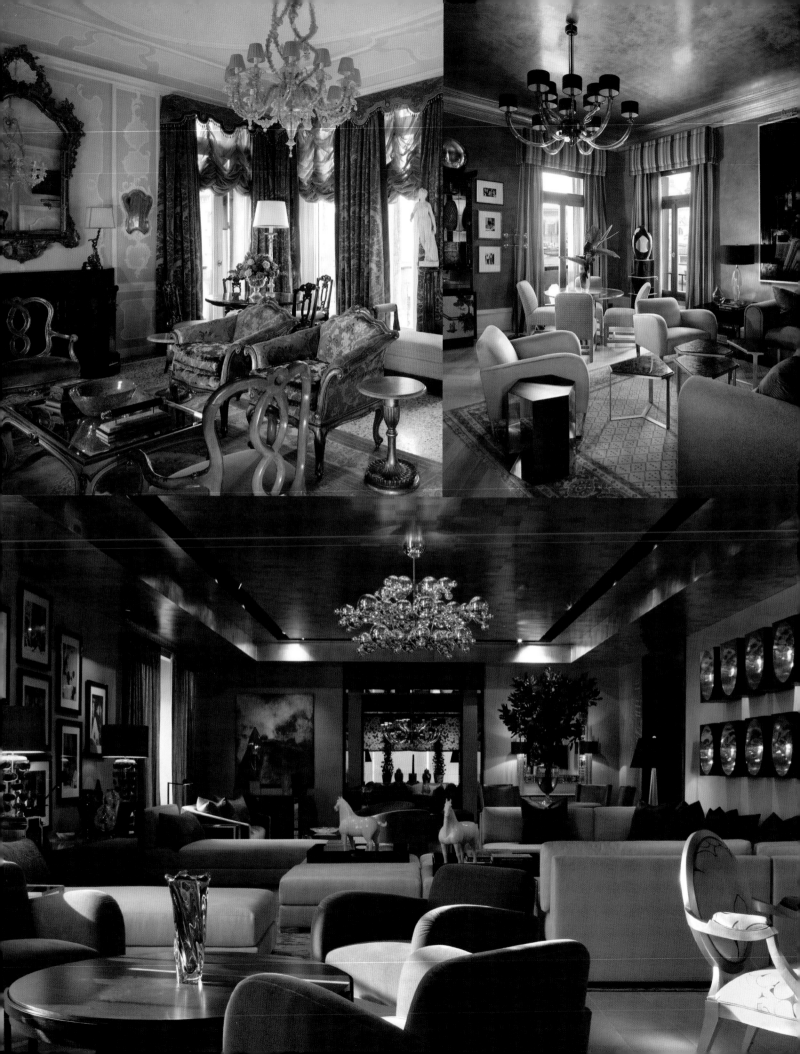

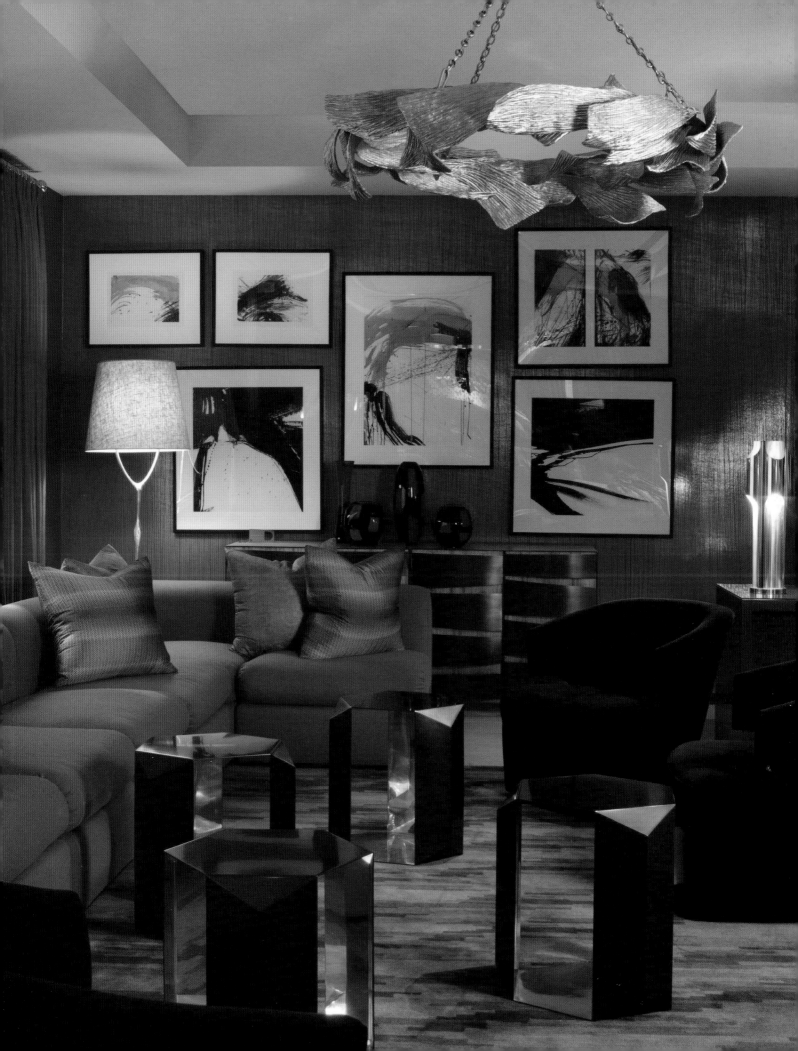

DAVID DOWNTON
Fashion Illustrator

When I wake up... I ring for breakfast. That is, when I'm enjoying my "gig of the century" as Artist in Residence at Claridge's hotel in London. If I'm at home, I get up and wonder why I'm the only member of my family capable of picking a damp towel off the floor.

Before I go to bed... I replay *Mad Men* episodes in my head. It's an addiction.

A well-dressed man... gets upgraded.

Women should always... accept a compliment.

Men should never... hold out for one.

The best thing that's been said about me... doesn't come close to describing my wit, wisdom, talent or dynamite looks.

The biggest misconception about me... is that I am delusional and an egomaniac.

If I weren't doing what I'm doing today... I'd be hell to live with.

My legacy... has been spent.

A great idea... should always be acted upon. Unless it's late and you're in a bar surrounded by strangers. In which case, call a cab.

Botox is... less effective than Photoshop.

My mother... is finally proud of me. I am an Honorary Doctor at two universities and a visiting professor at a third.

The soundtrack of my life... is BBC Radio 4. It's my education. I know a little about a lot.

The future... is right around the corner.

Happiness... needs to be lived, as well as remembered and anticipated. Now is what counts.

There's a time and place for... more or less everything.

There is too much... of more or less everything.

In the end... It's going to end?

Botox is . . . less effective than Photoshop.

DEBORAH LLOYD
Fashion Designer—Kate Spade

When I wake up... I smile.
Before I go to bed... I read a good book.
A well-dressed man... is worth a second glance.
Women should always... have a little mystery.
Men should never... wear bad shoes.
The best thing that's been said about me... don't prod the cobra!
The biggest misconception about me... I'm always right.
If I weren't doing what I'm doing today... I would be in my garden.

My legacy... is a bow.
A great idea... comes from anywhere.
Botox is... not for me.
My mother... is my biggest supporter.
The soundtrack of my life... "Where Do You Go to My Lovely."
The future... is a big adventure.
Happiness... is two black schnauzers called Stan and LuLu.
There's a time and place for... swearing.
There is too much... reality TV.

My legacy... is a bow.

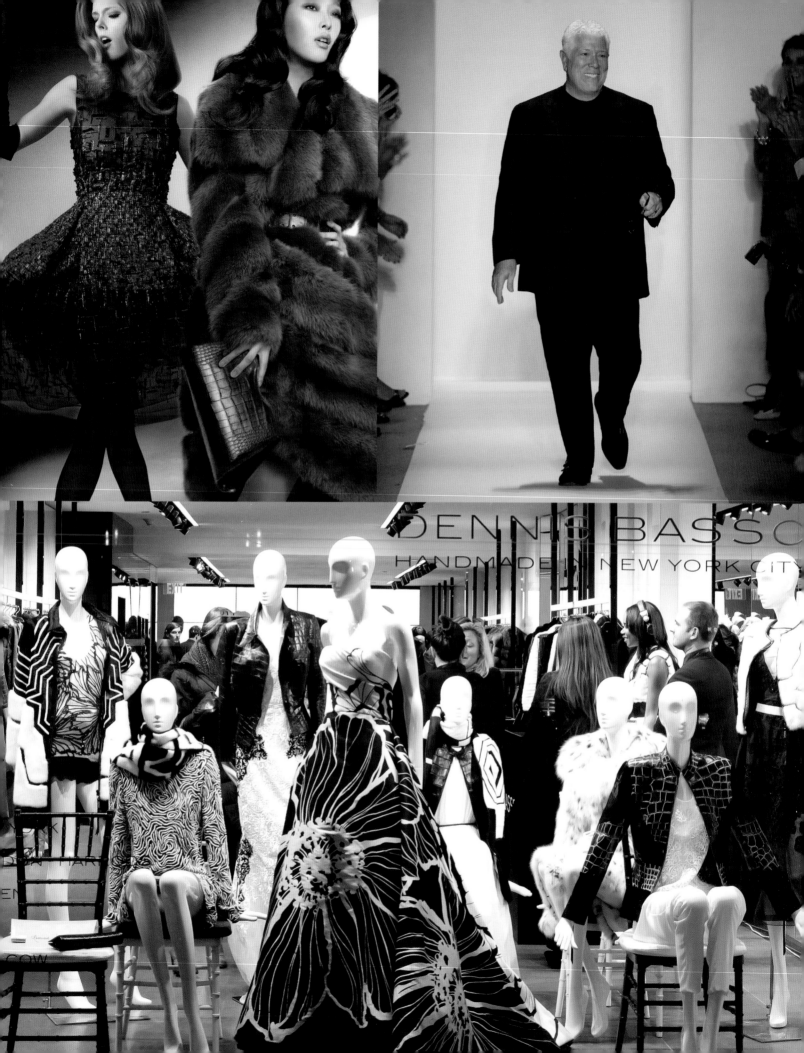

DENNIS BASSO
Fashion Designer

When I wake up... I'm always happy!

Before I go to bed... I always say a prayer.

A well-dressed woman... should have a great haircut and perfect manicure.

Women should always... feel beautiful, confident, and sexy!

Men should never... chew gum.

The best thing that's been said about me... is that I entertain beautifully.

The biggest misconception about me... is that I'm out all the time.

If I weren't doing what I'm doing today... I'd be in show business!

My legacy... will be for people to remember me for loving so many different types of people.

A great idea... is always fun to share.

Botox is... getting out of control.

My mother... was a spectacular woman.

The soundtrack of my life... "C'mon, get up and go!"

The future... is always full of surprises.

Happiness... is old friends.

There's a time and place for... work...and lots of play!

There is too much... jealousy in the world.

In the end... nothing is better than being in love.

In the end... nothing is better than being in love.

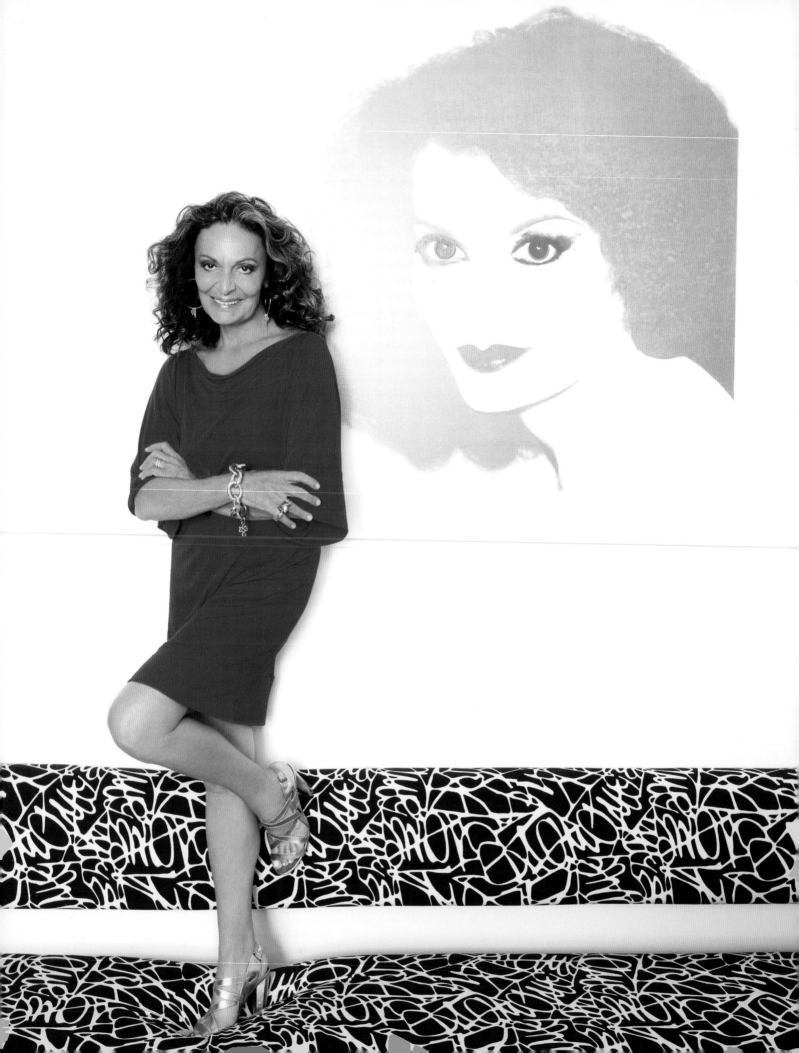

DIANE VON FURSTENBERG
Fashion Designer and Icon

When I wake up...I reach for my iPad. I sleep with it.

Before I go to bed...I take a hot bath.

A well-dressed woman...should be confident.

Women should always...wear perfume.

Men should never...underestimate a woman.

The best thing that's been said about me... oh I don't know. People say I have great legs and that is always nice to hear.

The biggest misconception about me...I don't think there are many misconceptions. I have no skeletons and I'm very open, so what people see is what they get.

If I weren't doing what I'm doing today... I would love to be a director or a playwright. Fashion is storytelling in its own way, but I have always been drawn to other forms of it.

My legacy...my children, of course. And hopefully that I have empowered women. That I have made them feel confident and beautiful.

A great idea...is my Harper connect handbag! I am obsessed. It has a special pocket for your iPad. It is genius!

Botox is...not for me. I don't judge other people but my face shows that I have lived. Why would I want to change that?

My mother...was a Holocaust survivor who taught me that fear is not an option. I have never forgotten it. I have lived by it.

The soundtrack of my life...is classical music and I love opera. But I also love silence.

The future...is full of color!

Happiness...is knowing who you are and staying true to that.

There's a time and place for...indulgence, I think it is important to be disciplined with yourself, but you must have some little sins.

There is too much...hesitation. I say go for it!

In the end...you only regret the things you did not do.

My mother...was a Holocaust survivor who taught me that fear is not an option. I have never forgotten it. I have lived by it.

DIEGO UCHITEL
Photographer

When I wake up... unless I am traveling or shooting, I take my kids to school.

Before I go to bed... I check emails and Instagram one last time—I finally gave in and now I am hooked!

A well-dressed man/woman... will be shot by a street-style photographer.

Women should always... wear high heels.

Men should never... wear high heels.

The best thing that's been said about me... "Dude, you are living the dream!"

The biggest misconception about me... is that I don't care what other people think of me.

If I weren't doing what I'm doing today... I would be an architect or a designer of living spaces. Real estate is my porn!

My legacy... my children.

A great idea... is not necessarily the right one.

Botox is... not for me.

My mother... sadly, never met my wife and children.

The soundtrack of my life... always includes Neil Young, Bob Marley, and the Beatles.

The future... is digital.

Happiness... Asado!

There's a time and place for... not doing what is expected of you.

There is too much... expected of you.

In the end... it somehow all works out.

There's a time and place for... not doing what is expected of you.

DONNA KARAN
Fashion Designer

When I wake up... I start my day with a mind, body, soul practice—yoga, pilates, or meditation.

Before I go to bed... I review my day. And, maybe have a piece of dark chocolate.

Women should always... take care of themselves first. It makes you more equipped to take care of others.

Men should never... cheat on their significant others.

The best thing that's been said about me... that I'm a caring person.

The biggest misconception about me... that it's only chaos. Within all of this chaos there is a calm.

If I weren't doing what I'm doing today... I'd be traveling around the world on the back of a motorcycle.

My legacy... well, my hope is that I'll master the art of finding the balance between my family, my work and my self.

A great idea... the world needs to come together as one.

Botox is... my savior.

My mother... is the one where I get everything... my good side and my bad.

The soundtrack of my life is... Barbra.

Happiness... is within yourself.

There's a time and a place for... leaping out of the box... being ridiculous. It's important.

There is too much... everything! I really feel that we need to scale back and get to what is important on so many levels.

In the end... I'll be with Stephan.

There's a time and a place for... leaping out of the box... being ridiculous. It's important.

Eddie Borgo

EDDIE BORGO
Jewelry Designer

When I wake up... I drink coffee.

Before I go to bed... I read.

A well-dressed man/woman... has a signature.

Women should always... support other women.

Men should never... be impolite.

The best thing that's been said about me... I am sincere.

The biggest misconception about me... I am young.

If I weren't doing what I'm doing today... I would be trying.

My legacy... that's a difficult one... to attempt to leave something of significance behind.

A great idea... can inspire forever.

Botox is... unnecessary.

My mother... is a powerhouse.

The soundtrack of my life... David Bowie's *Space Oddity*.

The future... inevitable, indecipherable, now!

Happiness... comes and goes.

There's a time and place for... love.

There is too much... fast information.

In the end... it will all work out.

The future... inevitable, indecipherable, now!

ELAD YIFRACH
Founder—L'Objet

When I wake up... I do twenty minutes of Kundalini yoga and take a nice, long, invigorating shower.

Before I go to bed... I flip through design or travel magazines, or try to read more than a few pages of a book before passing out.

A well-dressed man... should always travel with a beautifully tailored navy suit.

Women should always... leave some things to the imagination.

Men should never... be bitchy.

The best thing that's been said about me... is that I'm kind.

The biggest misconception about me... well, I hope there are no misconceptions because what you see is what you get!

If I weren't doing what I'm doing today... I would own and teach at a yoga and wellness center.

My legacy... has yet to be realized.

A great idea... is almost always a simple one.

Botox is... whatever makes you feel good.

My mother... wishes I lived closer.

The soundtrack of my life... changes with my moods. Everything from opera to Rihanna.

The future... is what I design for, which makes it challenging to stay in the present.

Happiness... is the Mediterranean.

There's a time and place for... almost everything.

There is too much... drama!

In the end... it's all worth it.

The future... is what I design for, which makes it challenging to stay in the present.

ELIE TAHARI
Fashion Designer

When I wake up... I feel grateful for the day, whether it is sunny or cloudy.

Before I go to bed... I reflect on the day and always try to be thankful for my blessings.

A well-dressed woman... her outfit is never complete without a well-dressed attitude.

Women should always... wear clothes that are quieter than her—that way her true beauty can shine through.

Men should never... be afraid to wear color. I wear pops of neon almost everyday

The best thing that's been said about me... is that I have helped someone, because that is what I believe I was put here to do.

The biggest misconception about me... is that I am a woman! People see the name Elie and think that it is a woman's name. Once I was in an elevator with a woman and she was carrying my shopping bag I said "I see you brought some Elie Tahari clothes" and she said "I love HER designs."

If I weren't doing what I'm doing today... I would have been an architect. I have worked with so many amazing architects—Piero Lissoni, Christian Liagre—their work has helped inspire a lifestyle and I have seen influences from their work manifest in my collections. My spring/summer 2014 collection was inspired from the architecture of Brasilia, which the famed Oscar Niemeyer created.

My legacy... I want to be remembered for the caliber of person that I am and that I strive to be. At the end of the day fame and money mean nothing; it's how you lived your life that matters.

A great idea... can pop into your head at any moment. I always keep a note pad handy to jot down ideas

My mother... is the most amazing woman I know!

The soundtrack of my life... anything from the disco era, although lately I have been listening to Bebel Gilberto keeping in mind with my inspiration of Brasilia.

The future... looks bright with endless possibilities.

Happiness... is my children.

There's a time and place for... fun and a time and a place for work—work hard, play hard!

There is too much... negativity in the universe. I wish peace and tolerance for the world.

In the end... I just want to do good for the world, discover truth wherever it is.

In the end... I just want to do good for the world, discover truth wherever it is.

ELLIE CULLMAN
Interior Designer

When I wake up... I sip cappuccino with my husband, Edgar, and devour the papers.

When I go to bed... I'm exhausted from my skin regimen.

A well-dressed woman... stands up straight and looks you in the eye.

Women should always... have their own checking accounts and credit cards.

Men should never... wear tank tops or shorts with socks.

The best thing that's been said about me... *The Wall Street Journal* once called me a "stealth maximalist."

The biggest misconception about me... is that I only like folk art.

If I weren't doing what I'm doing today... I would be directing movies—or trying to at least!

My legacy... A good person who left a little bit of beauty in the world.

A great idea... Spanx and Post-it Notes— wish I had thought of those!

Botox is... inevitable.

My mother... never forgave me for dropping out of Harvard Law School.

The soundtrack of my life... is the jingle of my Cartier three color gold bangles, which I wear every day. They match everything, and the girls in the office can hear me coming.

The future... is around the corner, so enjoy your QTR (Quality Time Remaining).

Happiness... is sitting in a dark movie theater with a box of Goobers in one hand, and a box of Raisinettes in the other.

There's a time and a place for... relaxing... but I haven't found it yet.

There is too much... time spent on the computer, and not enough time spent with people face to face.

In the end... there's always leopard.

Women should always... have their own checking accounts and credit cards.

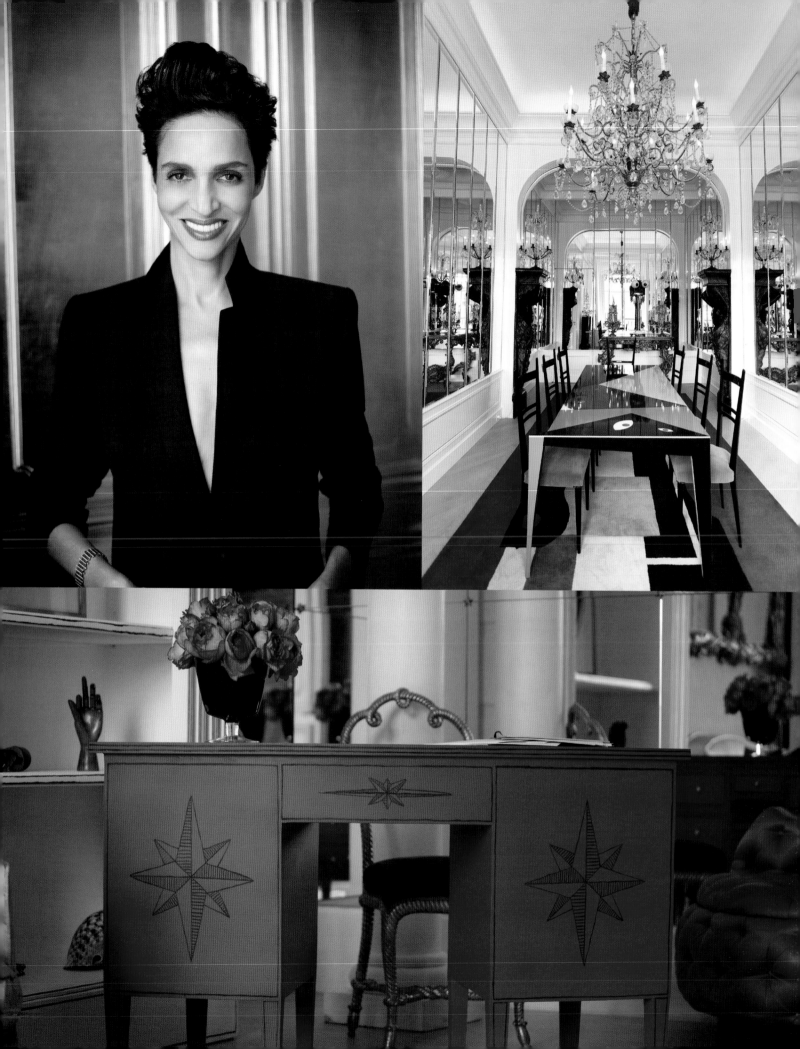

FARIDA KHELFA
Icon and Brand Ambassador—Schiaparelli

When I wake up... I meditate and drink a big coffee made with my Italian coffee pot.

Before I go to bed... I read.

A well-dressed man... should wear a perfectly tailored suit like Fred Astaire.

A well-dressed woman... should always wear a perfect dress and shoes.

Women should always... put on light makeup.

Men should never... be rude.

The best thing that's been said about me... I don't know, I still have not heard it!

The biggest misconception about me... is that people think I am tough, when I am really the opposite!

If I weren't doing what I'm doing today... I would be swimming in the sea.

My legacy... not much.

A great idea... I am waiting for it to come.

Botox is... not for me (even if I need it).

My mother... embodies the true meaning of courage.

The soundtrack of my life... depends on the year!

The future... is instantaneous (or the instant).

Happiness... is a perpetual quest.

There's a time and place for... your own privacy.

There is too much... violence.

In the end... we all seek for love.

My mother... embodies the true meaning of courage.

FIONA KOTUR
Bag Designer

When I wake up... it's like the starting pistol at the Kentucky Derby has just been fired—a mad dash to get everyone ready and out the door.

Before I go to bed... I share a glass of Bordeaux with my husband on our very, very long sofa, lounging toe to toe, with only the lights of Hong Kong and its skyline through the window... very peaceful.

A well-dressed man/woman... should never look like they're trying too hard.

Women should always... write hand-written thank you notes.

Men should never... go more than a week without calling their mothers—advice to my four sons upon maturity.

The best thing that's been said about me... was when one of my sons proposed to me... obviously he was very young, but it was so sweet and touching.

The biggest misconception about me... is that I shop a lot. I don't have much time, and I actually have a small-ish wardrobe. But I collect accessories, so the same few pieces of clothing are easily transformed beyond recognition.

If I weren't doing what I'm doing today... I would love to be a sculptor, though certainly I would be a starving one.

My legacy... are my beloved children... and a few little handbags that I hope will still look new and fresh even when I am old and wrinkly.

A great idea... is usually simple and touches the imagination.

Botox is... fine but sometimes creepy when overdone.

My mother... is a cross between Coco Chanel, Auntie Mame, and Lucille Ball, with Syd Charisse's legs... Michael Kors even commented on her 'great gams'!

The soundtrack of my life... Sinatra singing *Fly Me To The Moon*, Cole Porter's *Anything Goes*, and Bernstein's *On the Town* with a bit of *Amazing Journey* by Pete Townshend tossed in.

Happiness... is being inspired.

There's a time and place for... sleep, and I look forward to it.

There is too much... noise and cyber-stimulation. I work best and think most clearly at night when the world is asleep.

In the end... it all boils down to the simple things.

marrakesh marjelle garden

Sheila Camera Kotur 2013

There is too much … noise and cyber-stimulation. I work best and think most clearly at night when the world is asleep.

Surrealist

Sheila Camera Kotur 2013

GERT VOORJANS
Interior Designer

When I wake up... while taking a shower I imagine my outfit.

Before I go to bed... I contemplate tomorrow's schedule.

A well-dressed man... never carries a backpack.

Women should always... wear lipstick.

Men should never... wear shorts in town.

The best thing that's been said about me... is that I became who I wanted to be.

The biggest misconception about me... is that I am a Sunday child.

If I weren't doing what I'm doing today... I would be active in development aid.

My legacy... would be a more colorful world.

A great idea... is to integrate more art and green in public spaces.

Botox is... very useful in reconstructive surgery, but often misplaced in cosmetic surgery.

My mother... has strong views on individuality, personal point of views. Read no mainstream.

The soundtrack of my life... is Orefeo and Euridice by Christoph Willibald Gluck, 1714–1787, Vienna.

The future... is very challenging.

Happiness... is a state of mind.

There's a time and place... for serenity.

There is too much... "would be" and "look alike."

In the end... there is only the truth.

Botox is... very useful in reconstructive surgery, but often misplaced in cosmetic surgery.

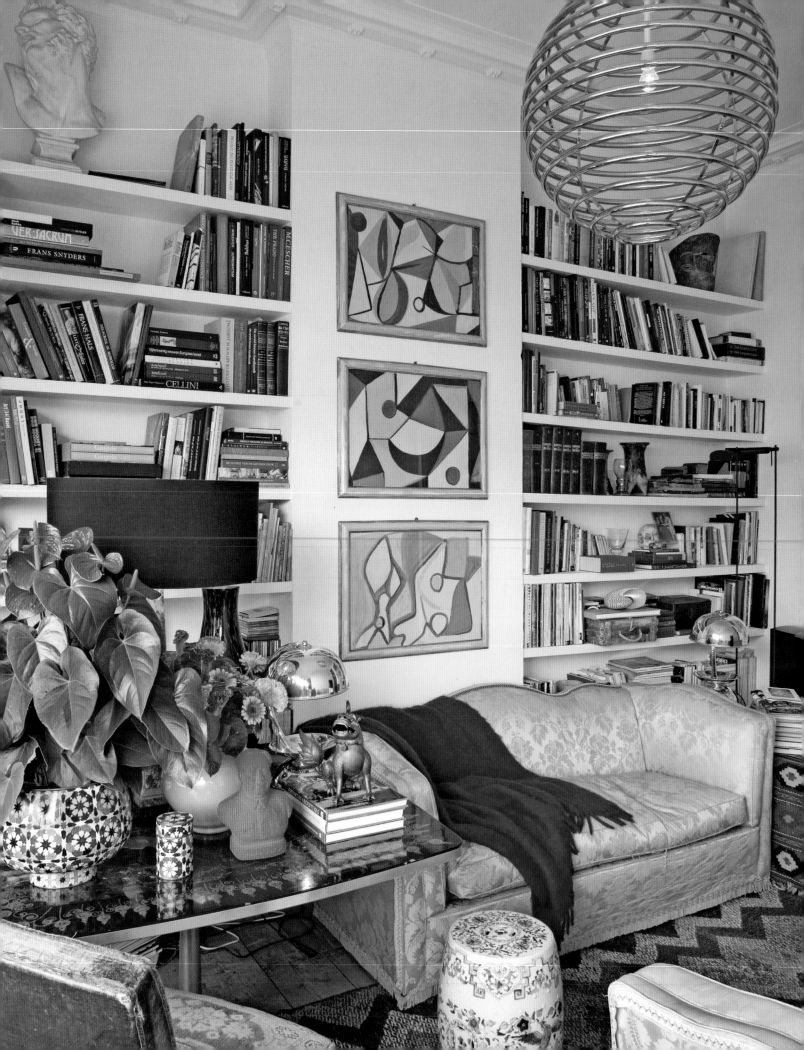

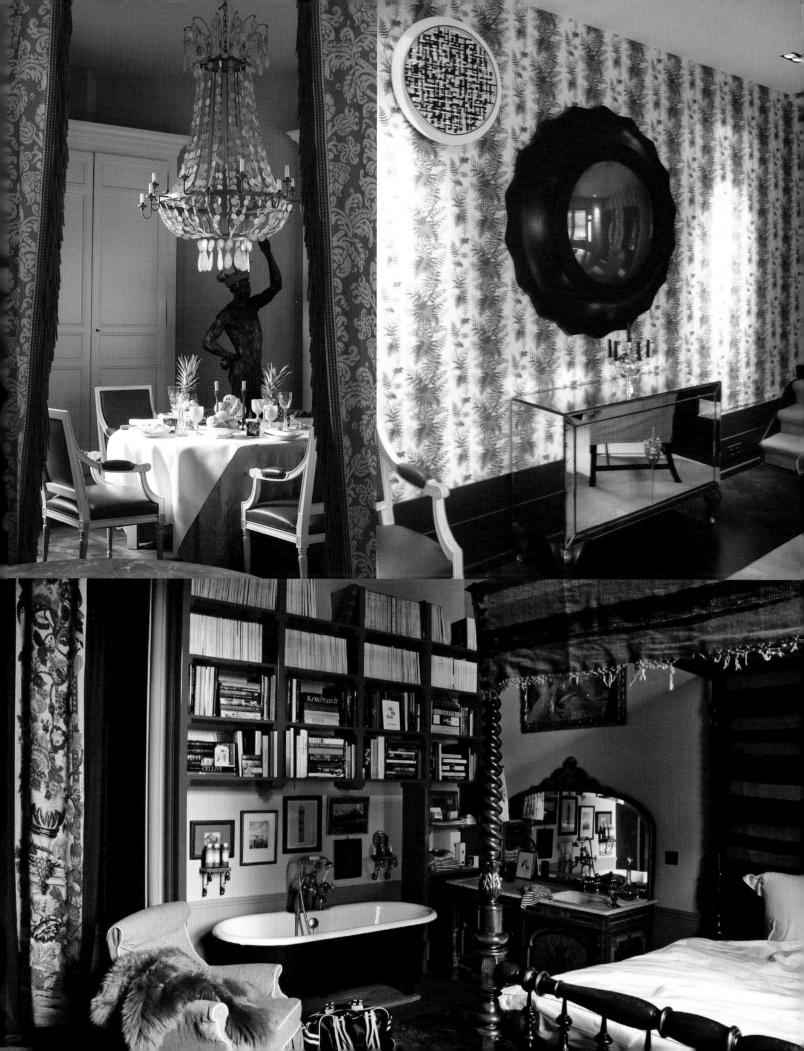

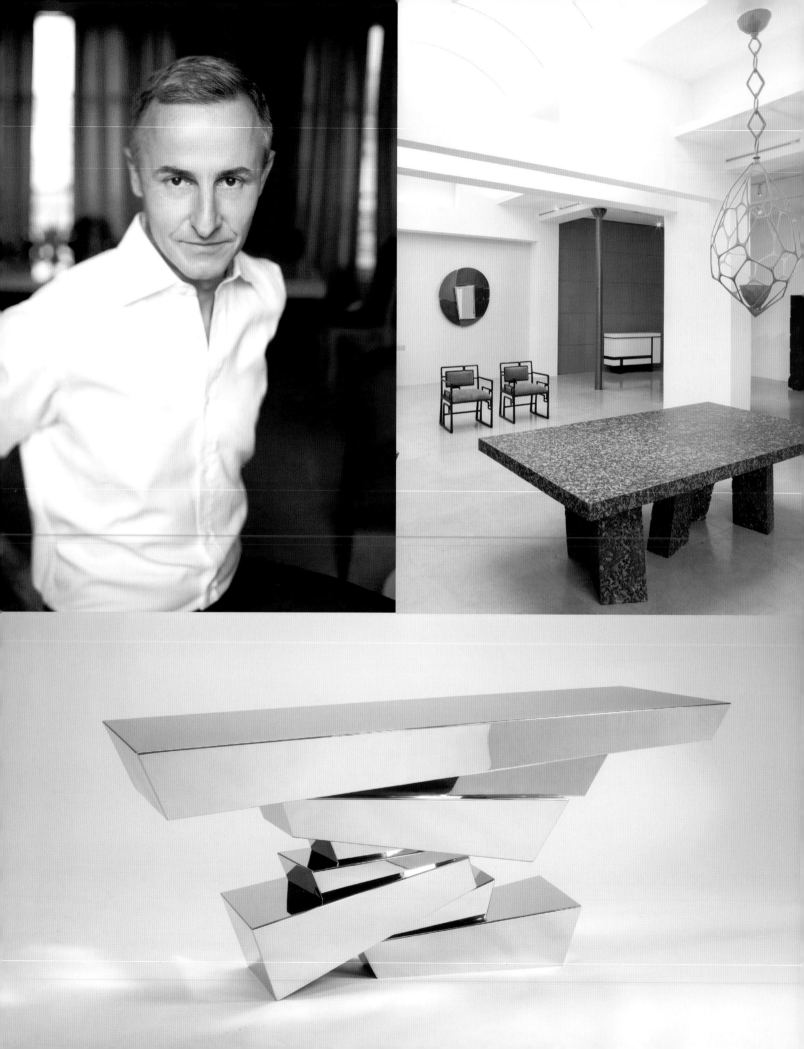

HERVE VAN DER STRAETEN
Furniture Designer

When I wake up... I don't want to waste time and rush out.

Before I go to bed... I always want to have done something fun or interesting.

A well-dressed man/woman... is rare.

Women should always... follow their moods.

Men should never... follow their moods.

The best thing that's been said about me... I am a faithful person.

The biggest misconception about me... some people see me as a very dry, serious guy. They can call anytime I will fix it.

If I weren't doing what I'm doing today... there would be many things I would enjoy, like being an architect, an actor, a cook...

My legacy... will be my furniture pieces. They are meant to last—in terms of design and quality.

A great idea... comes in a second and lasts forever.

Botox is... I don't have much opinion about it. I will try, and get back to you!

My mother... is fun, lively, and spiritual.

The soundtrack of my life... could be anything from Bach.

The future... is challenging and I like it.

Happiness... is like a garden; if you take care of it, it will be blooming.

There's a time and place for... having a rest with the one you love.

There is too much... greediness.

In the end... nature will have the last word.

Happiness... is like a garden; if you take care of it,
it will be blooming.

INDIA HICKS
Jewelry Designer and Muse

When I wake up... I look to see who I've just slept with. Could be David, a dachshund, or a child.

Before I go to bed... I start making lists for tomorrow.

A well-dressed man... is incredibly sexy.

Women should always... remain independent.

Men should never... tell you you're the oldest women they have ever slept with. As David did the other day. What a rotter.

The best thing that's been said to me... "I want to stay with you." My foster son told me, after his mother died.

The biggest misconception about me... is that my parents were a couple of hippies who dreamt up the name India during some kind of acid flashback.

If I weren't doing what I'm doing today... I'd be very, very bored. I may live near the beach. I don't want to lie on it.

My legacy... I could not claim to have one. My grandparents were Viceroy and Vicerene of India by my age. I've got to get a move on.

A great idea... is almost always an impossible one.

Botox is... conflicting.

My mother... is the center of my life. Engaging, enchanting, and witty, she has had a uniquely vantage window onto many important moments of the middle of the last century.

The soundtrack of my life... "Happy Birthday to You." I have five children. It always seems to be someone's flipping birthday.

The future... is always bright, as long as my family are happy, healthy, and safe.

Happiness... a big old bag of licorice.

There's a time and place for... internet shopping, and it's not late at night. The last time I shopped after midnight, two sets of sofas turned up instead of two sets of covers.

There is too much... dog shit in our garden.

In the end... we are simply dust.

The biggest misconception about me... is that my parents were a couple of hippies who dreamt up the name India during some kind of acid flashback.

INÈS DE LA FRESSANGE
Icon and Brand Ambassador—Roger Vivier

When I wake up... I smile even if I don't want to. It helps transform my ideas.

Before I go to bed... I apply Dior nail cream and Revitalift from L'Oréal. This is a religion.

A well-dressed man/woman... usually they are anonymous, but let's say Freida Pinto.

Women should always... have a sense of humor and clean teeth.

Men should never... be aggressive and stingy or wear short socks.

The best thing that's been said about me... "she is beyond stunning" but I can't remember who said it!

The biggest misconception about me... is that I have plenty of clothes.

If I weren't doing what I'm doing today... I'd be a psychoanalyst, painter, ebeniste, or gardener.

My legacy... is my imagination.

A great idea... is Nutella giving 1€ for every box sold to help alleviate starvation in the world.

Botox is... expensive, ephemeral, and awful.

My mother... is not really the grandmother of my children. It's a pity.

The soundtrack of my life... is "Douce France" by Charles Trenet.

The future... is about trying to stop talking about the past. People always ask me about the past.

Happiness... is having at least an "Ines" in this world!

There's a time and place for... everything you love. Just take time to make a list of your priorities.

There is too much... waste. Waste of food, waste of money, waste of time, waste of words.

In the end... I am happy. I know it and I hope you are too!

The biggest misconception about me… is that I have plenty of clothes.

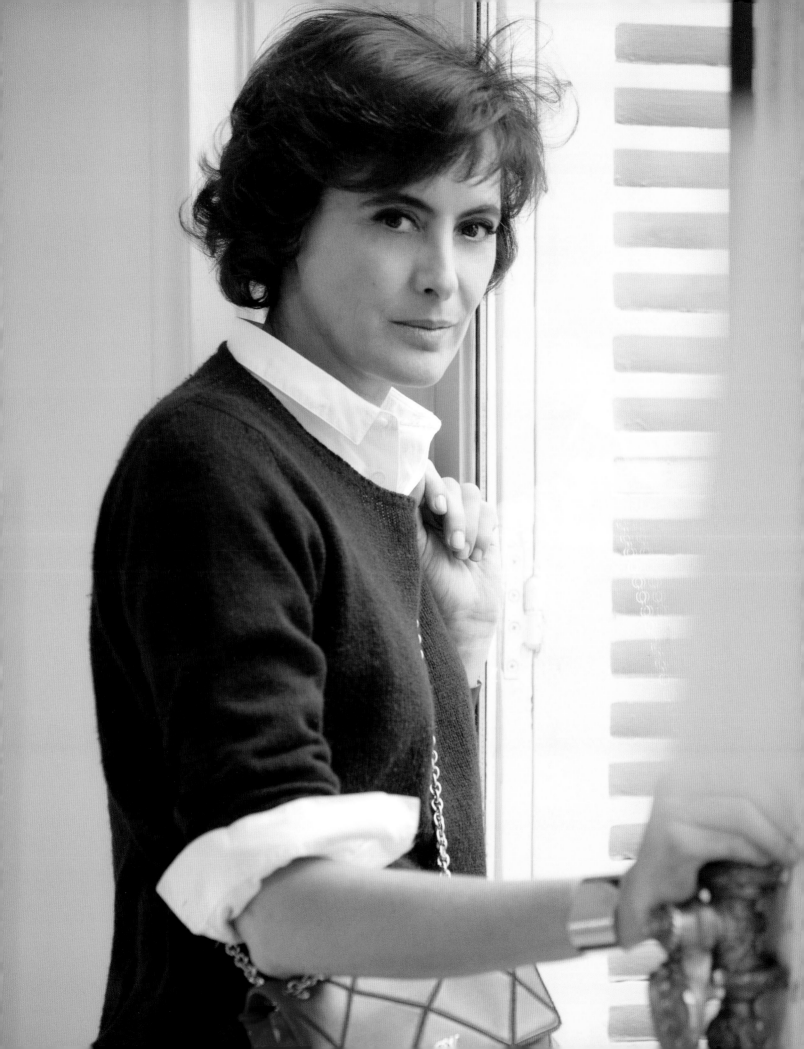

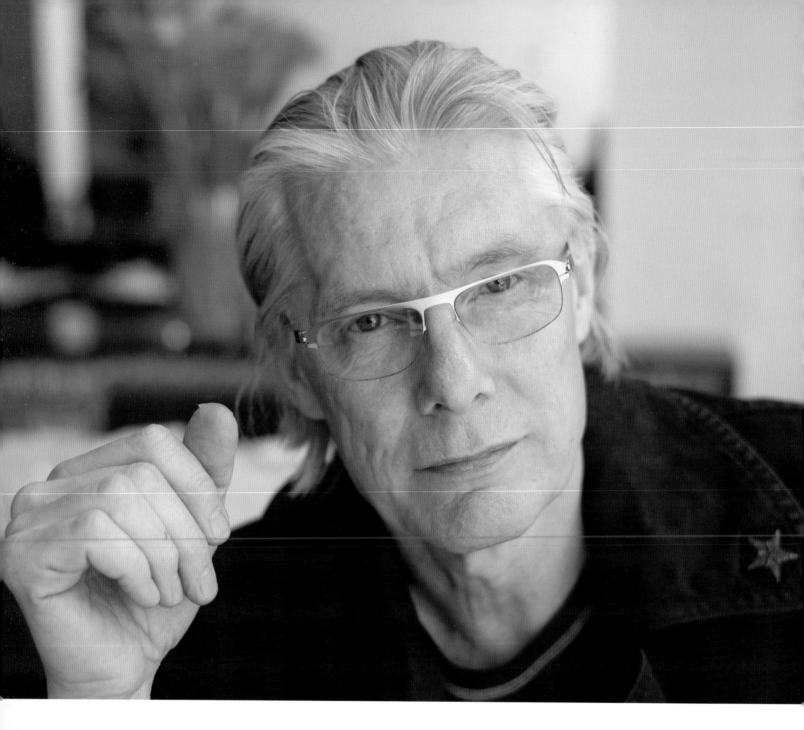

JAMES NARES
Artist

When I wake up... I smile.

Before I go to bed... I open the window... and smile.

A well-dressed woman... is like a good meal—it looks good, feels good, and by golly, it does you good.

Women should always... be kind.

Men should never... be unkind.

The best thing that's been said about me... is that I "shoot one helluva game of three cushion billiards." I said that about myself.

The biggest misconception about me... is that I'm not aggressive. Anyone who thinks that has never been a passenger in my car.

If I weren't doing what I'm doing today... I wouldn't be here. Wouldn't want to be.

My legacy... will surely be decided by someone other than myself.

A great idea... may turn out not to be so great after all. When I was a kid I thought it would be really cool to paint our neighbors' rhododendrons with bright red household enamel. I couldn't understand why they were so upset.

Botox is... a good way to make yourself look like you've been punched in the face.

My mother... should be on television. It would be the kind of show you couldn't not watch.

The soundtrack of my life... would be dominated by the music of Jimi Hendrix, John Coltrane, Thurston Moore, and Alan Vega.

The future... is to a fish, what a woman is to a bicycle (don't ask).

Happiness... is happening all around us.

There's a time and place for... just about everything except Botox.

There is too much... ignorance and hatred in this world.

In the end... is a new beginning—either that or a big black hole.

The biggest misconception about me... is that I'm not aggressive. Anyone who thinks that has never been a passenger in my car.

JEFFREY ALAN MARKS
Interior Designer

When I wake up... I go for a run on the beach with my dogs.

Before I go to bed... I sneak down to the butler's pantry for some homemade oatmeal cookies and milk. They make me sleep well.

A well-dressed man... has a classic foundation.

Women should always... dress in pretty colors. Black is for widows.

Men should never... wear bad un-tailored khakis.

The best thing that's been said about me... is that I have a playful attitude towards life.

The biggest misconception about me... is that I only do traditional.

If I weren't doing what I'm doing today... I'd be an English pop star.

My legacy... ask me at fifty.

A great idea... is anything that makes life easier.

Botox is... so 2001.

My mother... can do twenty things at once.

The soundtrack of my life... anything from the seventies.

The future... is a lot of lemonade and a beach house in Montecito.

Happiness... is being in Aspen with my boyfriend and my dogs.

There's a time and place for... dancing and tequila shots.

There is too much... designer crap in the world.

In the end... a good laugh is what matters.

The future... is a lot of lemonade and a beach house in Montecito.

JENNY PACKHAM
Fashion Designer

When I wake up...I count my blessings.
Before I go to bed...I smother myself in oils in the hope of eternal youth.
A well-dressed woman...moves without restriction.
Women should always...compliment each other.
Men should never...wear flip flops.
The best thing that's been said about me...is that I am modest.
The biggest misconception about me...is that I am modest.
If I weren't doing what I'm doing today...I would be a burlesque dancer.

My legacy...is my daughters.
A great idea...is to laugh in the face of adversity.
Botox...is the devil's work.
My mother...was fabulous.
The soundtrack of my life...is Schubert with a bit of grimey dubstep.
The future...is something to look forward to.
Happiness...is a smiling teenager.
There's a time and place...for free speech.
There is too much...fur being worn!
In the end..."It's better to have loved and lost than to never have loved at all."

Before I go to bed...I smother myself in oils in the hope of eternal youth.

JEREMIAH GOODMAN
Artist

When I wake up... I pray that I will wake up tomorrow.

Before I go to bed... I hope there's no one in it.

A well-dressed man/woman... looks natural.

Women should always be... ladylike.

Men should never... count on a woman.

The best thing that's been said about me... I don't get angry, I get even.

The biggest misconception about me... is that I am not adorable.

If I weren't doing what I'm doing... I would be guilt-ridden that time was getting the best of me.

My legacy... I was totally Jeremiah.

A great idea... I have too many.

Botox is... the most perfect counterfeit ever.

My mother... had eyes in the back of her head. She saw everything

The soundtrack of my life... I've always been told that I speak in Rumba time

The future... has to be better than the past.

Happiness... you never know it when you have it.

There's a time and a place for... being rude.

There is too much... negativity in the world.

In the end... I did the best that I could.

In the end . . .
I did the best that
I could.

JOHN VARVATOS
Fashion Designer

When I wake up... I can't wait to see my daughter Thea.

Before I go to bed... I check my schedule for the next day.

A well dressed man/woman... is more about how they carry themselves than the clothes they wear.

Women should always... be confident.

Men should never... underestimate a woman.

The best thing that's been said about me... is that I'm passionate.

The biggest misconception about me... is that I'm laid back.

If I weren't doing what I'm doing today... I'd be doing something in music or architecture.

My legacy... are my children.

A great idea... creates the need for another great idea.

Botox... is not for me.

My mother... I miss her every day.

The soundtrack of my life... It's all the great music to come out of my hometown, Detroit.

The future... is filled with endless possibilities.

Happiness... is being with my family and friends.

There's a time and a place for... tequila!!

There is too much... to do and not enough time.

In the end... It's only rock 'n' roll, but I love it!

The soundtrack of my life... It's all the great music to come out of my hometown, Detroit.

JONATHAN ADLER
Interior Designer and Potter

When I wake up... I pretend to still be asleep in the hope that my hubby, Simon, will wake up and take our Norwich Terrier Liberace out for a walk.

Before I go to bed... I look in the mirror and tell myself that I'm good enough, I'm smart enough, and people like me.

A well-dressed man/woman... is quirky. Style innovation is driven by outliers.

Women should always... smile.

Men should never... whine.

The best thing that's been said about me... My employees tease me by calling me "America's most famous potter." What more could a guy ask for?

The biggest misconception about me... is that I'm wacky. I'm very serious about what I do and I strive to make beautiful and well-crafted objects. Sadly, we seem to live in a world where the only way to be taken seriously as an artist or a designer is to be dour and obscurantist. I want my work to be serious and fun and communicative at the same time.

If I weren't doing what I'm doing today... I'd be unemployed. I was fired from every job I ever had because I was surly and inappropriate and engaged in all kinds of PG13 office hijinks.

My legacy... is, I hope, great design that will be appreciated in the future. My motto is "If your heirs won't fight over it, I won't make it."

A great idea... would be for someone to make a really good apple pie that is fat free.

Botox is... fine. Whatever gets you through the day. But, men shouldn't do anything to their faces. Never a good idea.

My mother... taugh me to never be banal. She has never said, "I find you can't have a bad meal in Italy," or "Your parents must be very proud," and she never uses euphemisms. It's not "passed away," it's "dead." She's direct and unexpected and I adore her.

The soundtrack of my life... is embarrassingly Top 40. Keha, Keha, and more Ke$ha.

The future... is, I hope, as happy a time for me as the present.

Happiness... is going to sleep in my bedroom on Shelter Island with my husband and my dog, listening to the waves and watching the dying embers in my preway fireplace.

There's a time and place for... vulgarity. The time is always and the place is right here.

There is too much... negativity and vitriol on the Internet.

In the end... I hope the stuff that I've made brings people joy for generations to come.

Before I go to bed... I look in the mirror and tell myself
that I'm good enough, I'm smart enough,
and people like me.

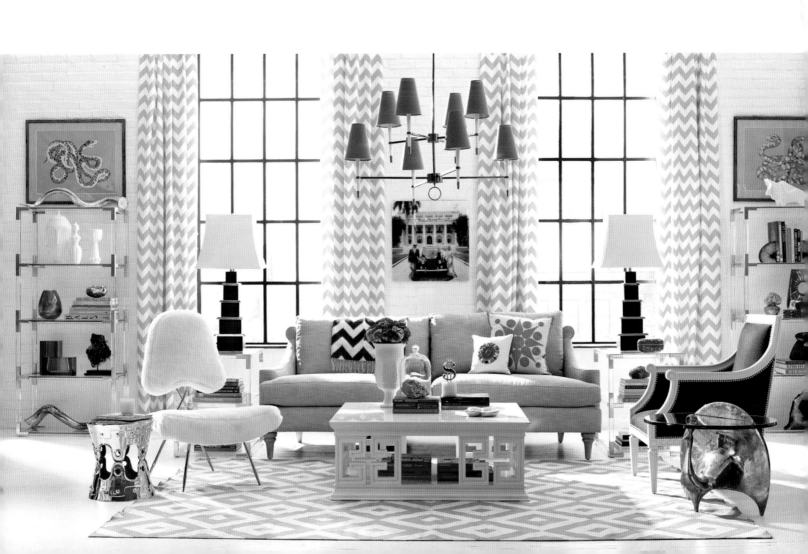

JORDI LABANDA
Fashion Illustrator

When I wake up...the first thing I do is look at the sky outside my window.

Before I go to bed...I think of the funny things that happened during my day.

A well-dressed man...doesn't pay attention to brands, just style.

Women should always...be true to themselves.

Men should never...know more about fashion than their girlfriend.

The best thing that's been said about me...is that I am responsible for resurrecting illustration as a communication tool.

The biggest misconception about me...is that I'm a dilettante that spends his days going from one party to another.

If I weren't doing what I'm doing today...I would be taking care of my garden in my house in Formentera.

My legacy...making illustration students want to be illustrators.

A great idea...often comes by in the most unexpected places.

Botox is...a frontier that a lot of women (and men) wished they had never crossed.

My mother...is always asking me if I'm eating well.

The soundtrack of my life...is full of songs by New Order, Franco Battiato, Björk, The Cure, Belle & Sebastian, Smashing Pumpkins, Sir...and much more.

The future...is always unpredictable, even for Susan Miller!

Happiness...is a bird of beautiful feathers that we do not see too often.

There's a time and place for...everything, as weird as that might sound.

There is too much...information.

In the end...truth is still in the things we liked when we were children.

In the end... the truth is still in the things we liked when we were children.

KAROLINA KURKOVA
Supermodel

When I wake up… I drink my hot water with lemon.

Before I go to bed… I read my son a bedtime story.

A well-dressed man… exudes confidence, elegance, and charm without being cocky.

Women should always… look neat and clean.

Men should never… wear square-toed shoes and white tennis socks with sandals.

The best thing that's been said about me… is that I am nice and funny.

The biggest misconception about me… that supermodels are not nice.

If I weren't doing what I'm doing today… I would be an archaeologist.

My legacy… that people will remember me as funny, real, and passionate.

A great idea… is when it gives you butterflies.

My mother… is Mother Theresa meets Grace Kelly meets Elizabeth Taylor.

The soundtrack of my life… something that's alive, upbeat, and happy meets something that's mysterious, quiet, and intense.

The future… is a mystery.

Happiness… is when you are at peace with yourself.

There's a time and place for… everything.

There is too much… sugar, wheat, and gluten.

In the end… it doesn't really matter.

The biggest misconception about me… that supermodels are not nice.

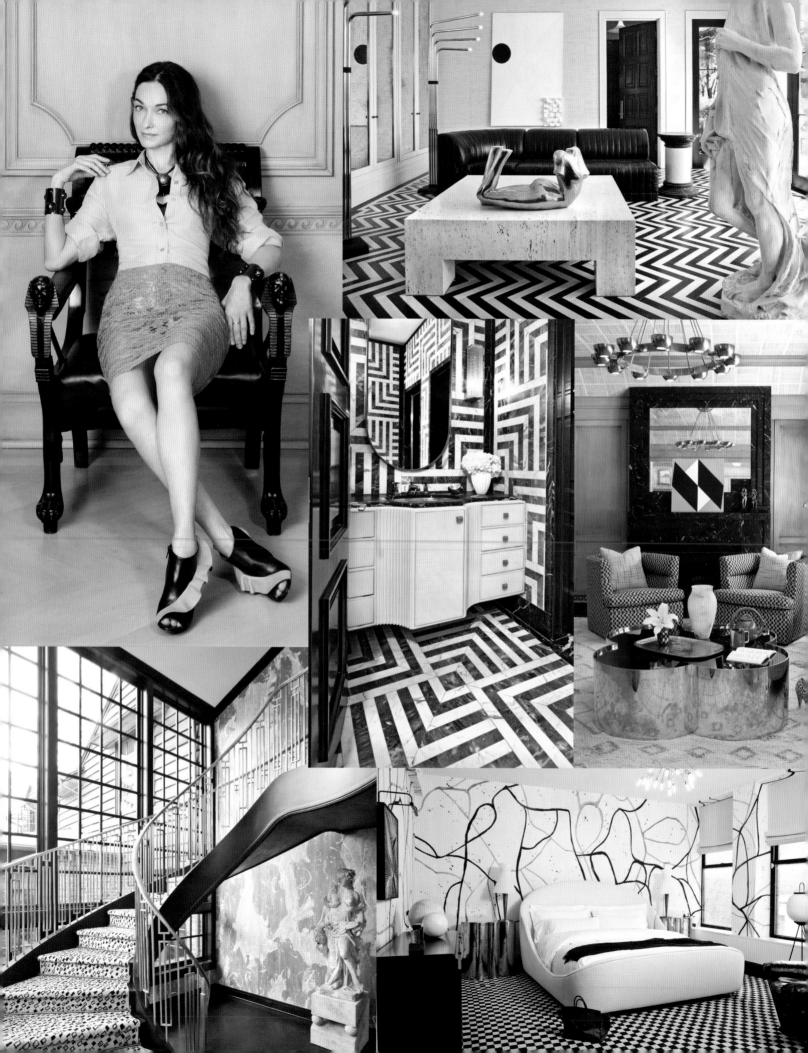

KELLY WEARSTLER
Interior Designer

When I wake up... I check on the boys and go to Barry's Bootcamp.

Before I go to bed... I snuggle and kiss my boys goodnight and look at my BlackBerry.

A well-dressed woman... should be chic and comfortable.

Women should always... keep a little mystery.

Men should never... lie to their mother.

The best thing that's been said about me... is that I stay calm under pressure.

The biggest misconception about me... is that I wear ball gowns to work.

If I weren't doing what I'm doing today... I'd be an artist or a painter. I need art around me always.

My legacy... is making the world a more colorful place.

A great idea... comes from endless curiosity.

Botox is... the bomb.

My mother... is hysterical. She's such a character!

The soundtrack of my life... is Alternative Nation.

The future... is bright.

Happiness... is being with my family and at work. I love both.

There's a time and place for... everything.

There is too much... fighting in the world.

In the end... it always works out.

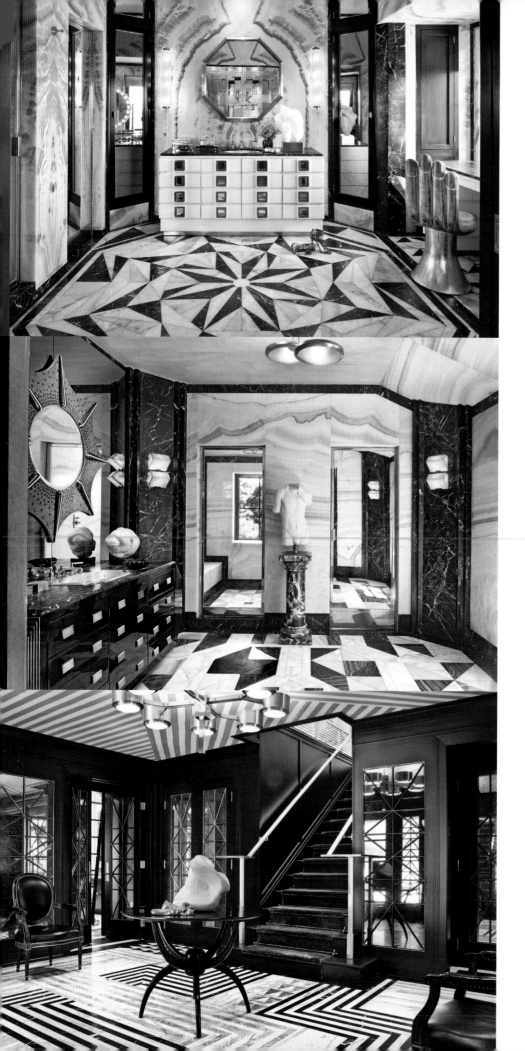

The biggest misconception about me... is that I wear ball gowns to work.

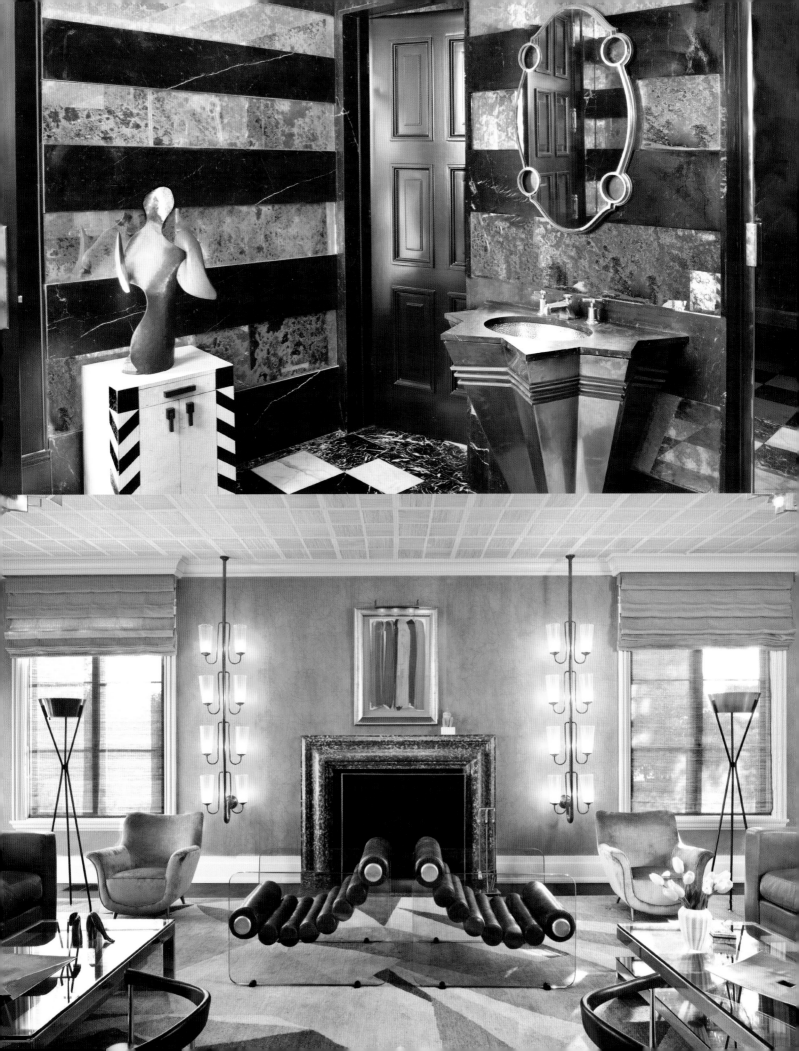

KIM SEYBERT
Designer

When I wake up . . . my dog Sophie snuggles with me.

Before I go to bed . . . I must read something.

A well-dressed woman . . . should dress age appropriately.

Women should always . . . keep some independence.

Men should never . . . be afraid to be vulnerable.

The best thing that's been said about me . . . is that I have a big heart.

If I weren't doing what I'm doing today . . . I would have five kids and be a stay-at-home mom.

My legacy . . . is being one of the pioneers of "fashion for the table" and elevating the art of setting the table to a new level.

A great idea . . . is simple and timeless.

Botox is . . . only good in moderation.

My mother . . . had a great sense of style.

The soundtrack of my life . . . *Someone Like You* by Van Morrison.

The future . . . is full of exciting possibility.

Happiness . . . is laughing until you cry!

There's a time and place for . . . being silly and acting like a child.

There is too much . . . unnecessary sharing of personal information.

In the end . . . what is important is living your life with character . . . honestly and fairly.

Happiness . . . is laughing until you cry!

LELA ROSE

LELA ROSE
Fashion Designer

When I wake up... I contemplate the run I desperately do not want to go on.

Before I go to bed... I plan what I am going to make for lunch the next day and wash my face with Clarisonic.

A well-dressed woman... wears many colors, not necessarily together. Just not basic black.

Women should always... stand up straight and be confident.

Men should never... be rude to their mothers. I have a son—this is a preventative measure.

The best thing that's been said about me... is that I am a great mother. It's only been said once but I am holding on to that!

The biggest misconception about me... is that I am a staunch Republican. I am independent.

If I weren't doing what I'm doing today... I would own a homemade ice cream store and spend the summer in Jackson Hole.

My legacy... Is hope I leave one!

A great idea... should be thought through to make it even greater.

Botox is... a beautiful thing, at least it makes a more beautiful face.

My mother... is tireless and a true inspiration.

The soundtrack of my life... Diana Ross's "Ain't No Mountain High Enough."

The future... comes too quickly.

Happiness... is a cold margarita and hanging on the stoop with the kids and husband.

There's a time and place for... a competitive game of Scrabble.

There is too much... work to be done before a fashion show!

In the end... I want to be happy about my choices.

Men should never... be rude to their mothers. I have a son—this is a preventative measure.

LELA ROSE

LUBOV AZRIA
Fashion Designer—BCBG Max Azria and Herve Leger

When I wake up... I think to myself, "How can I make it better?"

Before I go to bed... I thank God.

A well-dressed woman... deserves applause.

Women should always... take care of themselves.

Men should never... try to multi-task.

The best thing that's been said about me... "Are your lips real?"

The biggest misconception about me... is that I speak French.

If I weren't doing what I'm doing today... I would be a dancer.

My legacy... is to make this world a better place.

A great idea... requires follow-through.

Botox is... overrated.

My mother... is my soul sister.

The soundtrack of my life... is "Get Up, Stand Up" by Bob Marley.

The future... belongs to those who believe in the beauty of their dreams.

Happiness... is a state of mind.

There's a time and place for... everything.

There is too much... energy wasted on negativity.

In the end... it will all be ok.

A well-
dressed
woman…
deserves
applause.

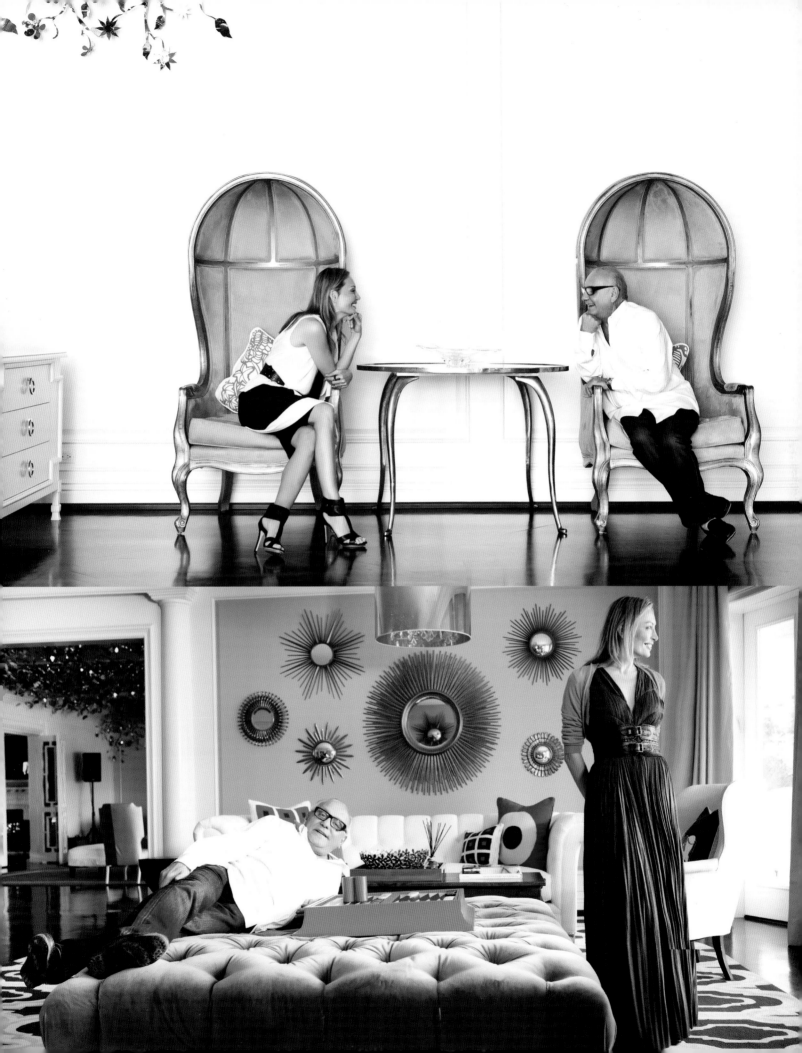

MARTYN LAWRENCE BULLARD
Interior Designer

When I wake up... I immediately have a cup of Earl Grey tea. I can't help it... my English roots!

Before I go to bed... I slap on my Strivectin face cream. It seems to be somewhat combating the signs of wear and tear on my weathered face.

A well-dressed man/woman... is always a delight. There's nothing more exciting than seeing people express their personal style through their dress sense.

Women should always... be elegant. There is nothing sexier than elegance (that goes for men too).

Men should never... forget their manners.

The best thing that's been said about me... is that I have a great sense of humor. Humor to me is everything.

The biggest misconception about me... is that I'm snobbish. I'm the least snobbish person I know!

If I weren't doing what I'm doing today... I would have loved to be a singer. I adore to sing. Just in the shower though these days.

My legacy... I hope will be the fabrics, furniture, fragrances, and decorative items I've had the pleasure to design. I hope generations in the future will continue to enjoy these.

A great idea... I to make sure we take time out of everyday to laugh. Laughter cures all, I believe.

Botox is... a clever tool when used in very small doses.

My mother... is an amazing woman who has been my number one fan and supported me unconditionally with her love and passion throughout my life in everything I have done. I'm very blessed.

The soundtrack of my life... would have to be "My Way," Frank Sinatra's version of course!

The future... is very exciting with amazing jobs and my products expanding around the world. I'm incredibly lucky and enjoy working incredibly hard to keep up my high standards on all of this.

Happiness... is sharing quality time with my family and friends.

There's a time and place for... all things!

There is too much... prejudice and hate in the world!

In the end... love will heal all.

The soundtrack of my life...

would have to be "My Way," Frank Sinatra's version of course!

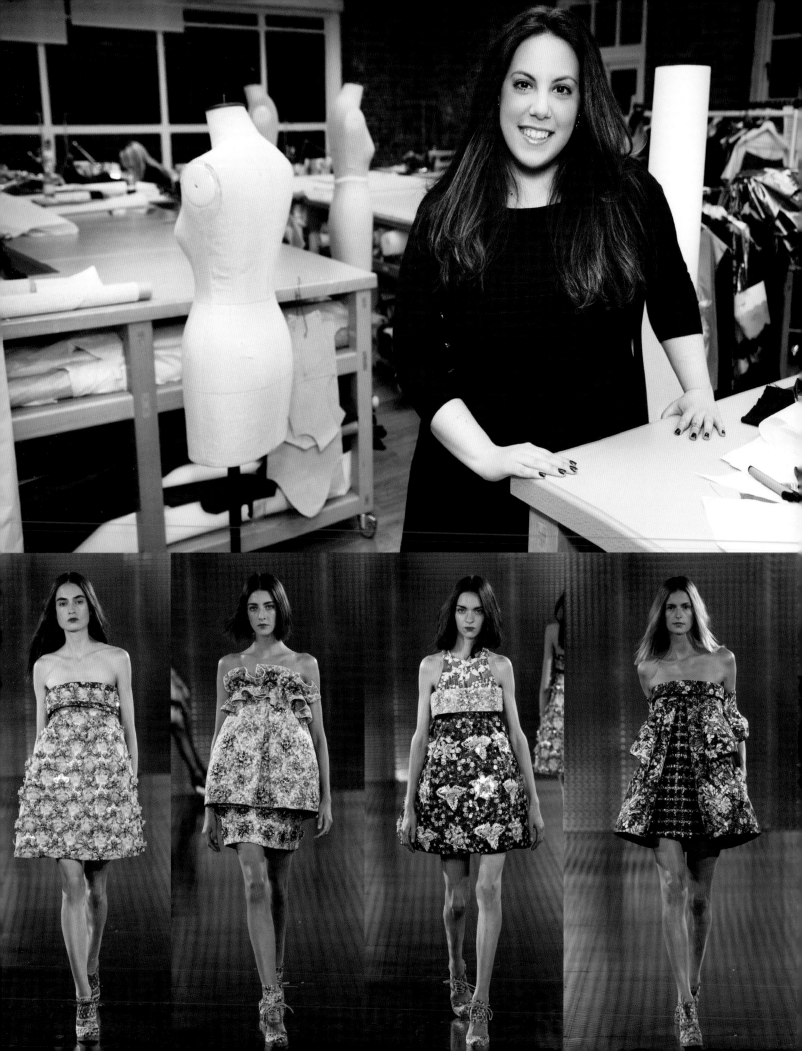

MARY KATRANTZOU
Fashion Designer

When I wake up... I normally make myself a cappuccino and check my emails at my desk before the day of work begins!

Before I go to bed... I always make sure I go through what I need to do the next day, that way I'm not awake all night thinking about it!

A well-dressed man/woman... never follows a trend. They have their own style and work the season's pieces around their own look. They wear the clothes and don't let the clothes wear them.

Women should always... wear fashion with confidence.

Men should never... be afraid to look as stylish as their female counterpart.

The best thing that's been said about me... was after my A/W13 show at London Fashion Week. The collection was a big step for me as it was basically rinsed of color. I was nervous about the reaction, but Suzy Menkes wrote in the *New York Times* that it "set the tone for the season."

The biggest misconception about me... is that I am a maximalist because of all the color and print I use. I am actually more of a minimalist at heart.

If I weren't doing what I'm doing today... I would be an architect.

My legacy... I hope, will be a part of how great British Fashion is, and that people are open to individuality and experimentation. Print has established itself in our times to be more than a trend. I hope that my work has allowed women to dress in a way that they couldn't dress before, indulging in fashion to define their taste and aesthetic. My work is about perception more than it is about print. It's about allowing women to wear the beauty found in design, in a subversive way.

A great idea... was the internet. I wish I had invented it!

Botox is... destroying natural beauty. The most beautiful older women I know have aged naturally and are glowing. That said, I believe beauty is in the eye of the beholder and everyone should be able to make their own decisions.

My mother... is my harshest critic, but I love her for it. In this business you need people that are going to be honest with you and challenge your opinions.

The future... is exciting for me at the moment. We have just launched our website and the next step will be a store hopefully.

Happiness... is relative to the individual.

There's a time and place for... relaxation, and I wish I knew where and when it was!

In the end... it will all be alright, and if it is not alright, it is not the end! One of my favorite sayings.

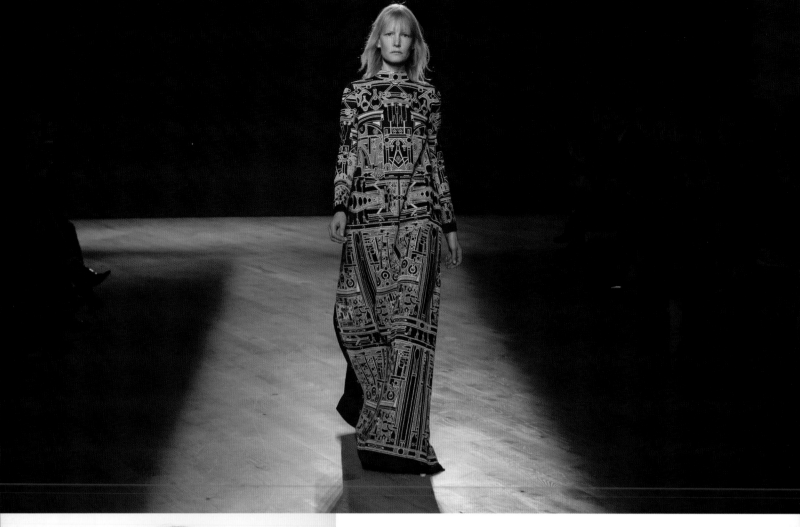

There's a time and place for... relaxation, and I wish I knew where and when it was!

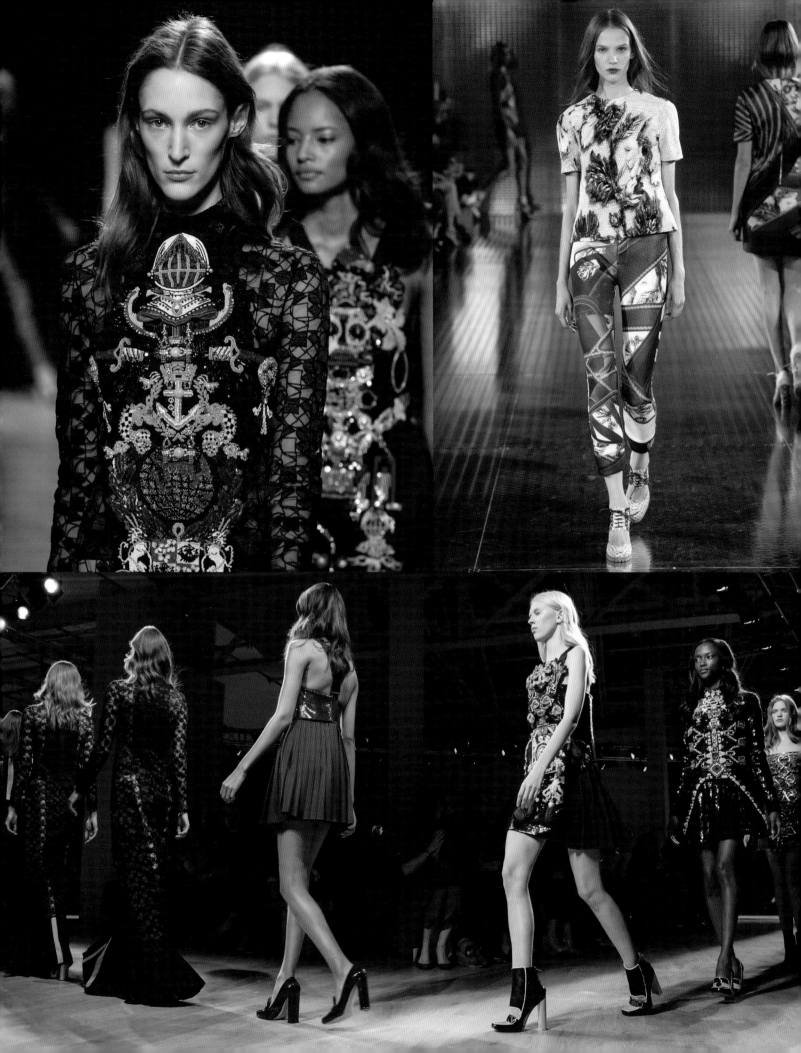

MARY MCDONALD
Interior Designer

When I wake up... I run to the coffee maker.

Before I go to bed... I choose one lucky pug for the night.

A well-dressed man/woman... always owns a starched white shirt.

Women should always... smell nice.

Men should never... wear short-sleeve dress shirts, and spitting is not so great either.

The best thing that's been said about me... I am hilarious.

The biggest misconception about me... is that I am a bitch.

If I weren't doing what I'm doing today... I would be lying down.

My legacy... is the designs I leave behind.

A great idea... is only ten percent of success.

Botox is... expensive.

My mother... was exactly like Melanie in *Gone with the Wind* in look and demeanor. I know, go figure.

The soundtrack of my life... is "Bohemian Rhapsody" by Queen.

The future... is full of endless possibilities.

Happiness... is my assistant, Kenna.

There's a time and place for... naughty antics.

There is too much... trashy behavior out there.

In the end... the people who truly love you are all that matters.

The biggest
misconception
about me...is
that I am a bitch.

MICHAEL BASTIAN
Fashion Designer

When I wake up... I immediately calculate how many times I can hit the snooze button.

Before I go to bed... I take my vitamins, brush my teeth, and read *The New Yorker* for a while.

A well-dressed man... really has the power to stop you in your tracks. You know it when you see it.

Women should always... flirt a little—even with other women and gay guys—there's something very charming about it, and it's immediately disarming. It's a strong weapon only women can deploy effectively.

Men should never... take themselves (or their work or their appearance) too seriously.

The best thing that's been said about me... on an anonymous blog someone wrote "this guy is just making stuff I want to wear."

The biggest misconception about me... is that I somehow planned the career I have right now. The trajectory of my life so far has all been a big surprise to me. It's made me a huge believer in fate and luck.

If I weren't doing what I'm doing today... I'd probably be in advertising or a teacher, like everyone else in my family.

My legacy... for better or worse, this is still being written at the moment. But I'd be very happy with it being "he was truly a nice and considerate guy."

A great idea... needs to be acted on immediately, given away or dropped. Great ideas are very much "of the moment" and endlessly mulling them over just takes up too much of your brain space, and might block your next great idea. Act on it, give it away or move on.

Botox is... a completely foreign concept to me. I really love expressive faces and it seems much "younger" to me to just be yourself and not broadcast your insecurities so loudly.

My mother... did an amazing job of giving her kids independence, which is a rare gift. I never doubted my place in the world.

The soundtrack of my life... seems to change each season and to be very connected to the collection I'm working on at the minute. It really helps me solidify the mood of the season.

The future... is looking very bright at the moment. The movie I seem to be living in has gotten really exciting in the past few years and I'm looking forward to seeing how it will all play out.

Happiness... is directly correlated to gratitude.

There's a time and place for... criticism. And too few people know when that is exactly.

There is too much... fast fashion in the world right now. How many landfills are being packed with cheap jeans and T-shirts, not to mention the human rights issues of producing massive amounts of disposable "fashion" in developing countries. It's got "bad karma" written all over it.

In the end... I hope all the pieces suddenly come together and it all makes sense. Please let there be this huge epiphany at the end!

Women should always... flirt a little—even with other women and gay guys—there's something very charming about it, and it's immediately disarming. It's a strong weapon only women can deploy effectively.

MICHAEL HERZ
Fashion Designer

When I wake up... I have a bath.
Before I go to bed... I brush my teeth.
A well-dressed woman... fills a room.
Women should always... be appreciated.
Men should never... think they're more important than they are.
The best thing that's been said about me... is that I am a pragmatist.
The biggest misconception about me... is that I'm a big party person.
If I weren't doing what I'm doing today... I'd be either a cowboy or an actor.
My legacy... is cooking wonderful dinners for my family and friends.

A great idea... is something I secretly covet.
Botox is... a personal choice.
My mother... has great style.
The soundtrack of my life... is Madonna's "Cherish."
The future... is now.
Happiness... is being at home.
There's a time and place for... drinking champagne!
There is too much... going on!
In the end... love it or leave it.

Men should never... think they're more important than they are.

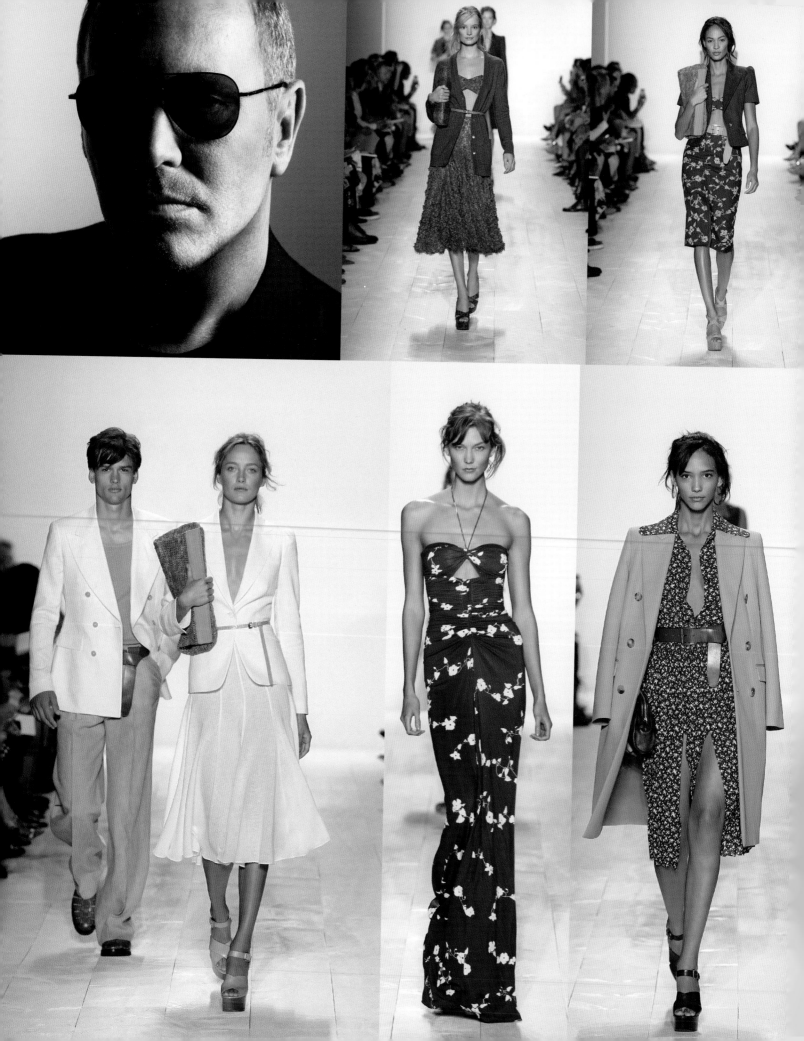

MICHAEL KORS
Fashion Designer

When I wake up...I feed my cats, Bunny and Viola.

Before I go to bed...I watch something that lets me shut my brain off, like *Ru Paul's Drag Race*.

A well-dressed man...has a good tailor.

Women should always...wear what makes them feel confident.

Men should never...wear short shorts off a playing field, beach, or tennis court.

The best thing that's been said about me...is that I'm a great and loyal friend.

The biggest misconception about me...is that I'm not serious.

If I weren't doing what I'm doing today...I'd be a Broadway producer.

My legacy...is relaxed, sexy American glamour.

A great idea...calorie-free Doritos that taste the same as the original.

Botox is...a great invention.

My mother...always told me "stay true to yourself."

The soundtrack of my life...*Native New Yorker.*

The future...is full of surprises.

Happiness...is a beautiful beach with friends and family. And no cell phone or calendar.

There's a time and place for...a sky-high stiletto.

There is too much...hunger throughout the world. But we're working with the United Nations World Food Programme (WFP) to help end that.

In the end...it's all about empathy.

My legacy...is relaxed, sexy American glamour.

MILAN VUKMIROVIC
Fashion Designer and Editor

When I wake up... I feel happy and lucky to be next to the person I love.

Before I go to bed... I take the person I love in my arms.

A well-dressed man... knows how to wear clothes which can only enhance his personality, his beauty, or sex appeal. It's about being confident and cool with yourself.

Women should always... avoid tattoos.

Men should never... wear white leather shoes.

The best thing that's been said about me... is that I am a multi-talented and free spirited person.

The biggest misconception about me... I am very shy and some people take it as me being cold or arrogant.

If I weren't doing what I'm doing today... I would be a psychologist.

My legacy... is all I create.

A great idea... always the next one.

Botox is... not cool.

My mother... is only love.

The soundtrack of my life... always a work in progress.

The future... is now.

Happiness... is enjoying the most simple moments of life with your loved one.

There's a time and place for... any of our dreams.

There is too much... stressed people.

In the end... love and be loved in return is only what matters.

When I wake up... I feel happy and lucky to be next to the person I love.

MILES REDD
Interior Designer

When I wake up... I start making lists and expecting things.

Before I go to bed... I draw the curtains.

A well-dressed man... owns the room, because clothes are confidence.

Women should always... go to Paris.

Men should never... say never, because one never knows.

The best thing that's been said about me... is that I am not generic, by Hamish Bowles.

The biggest misconception about me... is that I'm gregarious. I'm actually quite shy.

If I weren't doing what I'm doing today... I think I would be a painter or an artist.

My legacy... is my family.

A great idea... is something rare. That's why they are great ideas.

Botox is... injecting botulism into your skin to get rid of wrinkles.

My mother... is a saint who likes a party.

The soundtrack of my life... is ever-changing.

The future... holds lots of promise—it does get better.

Happiness... is perspective—how you look at things.

There's a time and place for... everything!

There is too much... email—technology is making life tedious.

In the end... the meek shall inherit the Earth.

A well-dressed man... owns the room, because clothes are confidence.

NATHAN TURNER
Interior Designer

When I wake up... I take my dogs down to the beach.

Before I go to bed... I clear my head.

A well-dressed woman... should know when to edit.

Women should always... have a voice.

Men should never... brag.

The best thing that's been said about me... is that I'm kind.

The biggest misconception about me... is that I'm uptight.

If I weren't doing what I'm doing today... I'd be a country western singer.

My legacy... is relaxed American style.

A great idea... is the sandwich, the taco, and the crepe...I love portable meals.

Botox is... fine in moderation, if it makes you feel good.

My mother... taught me to be charitable.

The future... is unknown...that's what makes it so exciting.

Happiness... is a choice.

There's a time and place for... sarcasm.

There is too much... bad behavior on TV.

In the end... the only things that matter are your friends and family.

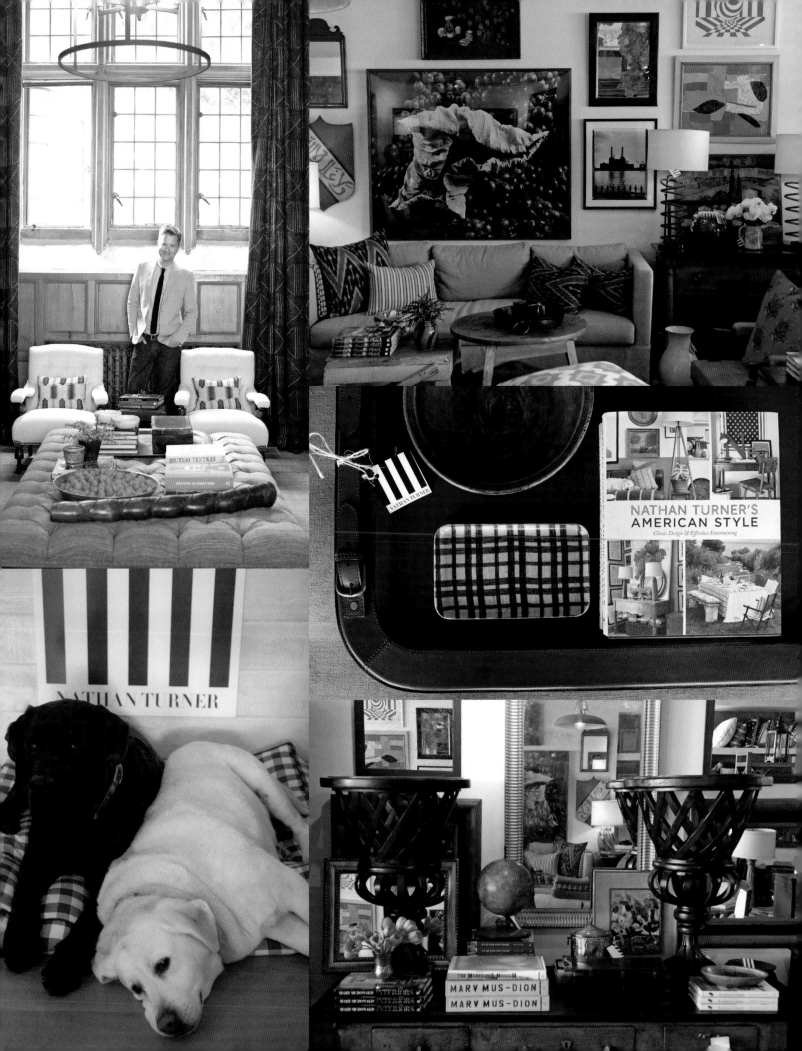

NATHAN TURNER

NATHAN TURNER'S
AMERICAN STYLE
Classic Design & Effortless Entertaining

MARY MUS–DION
MARY MUS–DION

A great idea... is the sandwich, the taco and the crepe...I love portable meals.

OLIVIA CHANTECAILLE
Style and Beauty Icon

When I wake up... I check my emails that have come in from Asia and Europe.

Before I go to bed... I kiss my husband goodnight and think of ten good things that I am grateful for that day.

A well-dressed man... has self-respect.

Women should always... smile.

Men should never... ask a woman her age.

The best thing that's been said about me... is that I made someone happy.

The biggest misconception about me... is that I can't cook.

If I weren't doing what I'm doing today... I would have a lifestyle TV show.

My legacy... is that I helped women to feel beautiful and great about themselves.

A great idea... was to work with my mother on launching our cosmetics company.

Botox is... optional.

My mother... is an AMAZING woman!

The soundtrack of my life... is dance music.

The future... is only getting better.

Happiness... is the overwhelming feeling of love and joy.

There's a time and place for... talking about money.

There is too much... waste.

In the end... my life was better than I ever expected.

In the end... my life was better than I ever expected.

If I weren't doing what I'm doing today... I'd be doing it tomorrow. I can't imagine not making photographs.

PAUL LANGE
Photographer

When I wake up... I kiss my wife.

Before I go to bed... she kisses me.

A well-dressed man... should wear their hearts on their sleeves.

Women should always... be nice to my boys.

Men should never... be arrogant.

The best thing that's been said about me... is that I'm kind and caring... or was it kind of?

The biggest misconception about me... is that I work alone. My wife and I have worked together as business and creative partners for the last thirty-five years.

If I weren't doing what I'm doing today... I'd be doing it tomorrow. I can't imagine not making photographs.

My legacy... my two talented sons, Matthew and Christopher.

A great idea... requires great actions.

Botox is... not in my future.

My mother... is an amazing and active woman at ninety-one and she loves a good cup of tea.

The soundtrack of my life... the click of my camera.

The future... a cottage on the Maine coastline.

Happiness... is being with the ones I love.

There's a time and place for... kindness—always and everywhere.

There is too much... to do in a day and not enough time for reflection.

In the end... I love the roller coaster of my life.

PAUL SMITH
Fashion Designer

When I wake up... I can honestly say, every day, that I feel very positive. Aren't I lucky?

Before I go to bed... I don't think of anything as I have normally had such a long day as I get to work at 6 a.m. every morning (after a swim) and don't stop all day.

A well-dressed man/woman... knows themselves well, respects their body shape and size and understands age and lifestyle. Keep it simple!

Women should always... be well groomed with freshly cleaned hair, good nails, and above all, good posture.

Men should never... dress in a way that is inappropriate for their age and lifestyle.

The best thing that's been said about me... is that I'm a nice, normal, down to earth guy... thank you.

The biggest misconception about me... no idea!

If I weren't doing what I'm doing today... I would probably be a photographer as I spend a lot of time taking photos for magazines and also shoot all my own advertising campaigns.

My legacy... is running a business from the heart, not for the wallet.

A great idea... should come from thinking laterally and never following the obvious route.

Botox is... normally a failure.

My mother... had a beautiful voice.

The soundtrack of my life... who knows! It could be Van Morrison, Puccini or Jake Bugg!

The future... more of the same please!

Happiness... is always there you just have to understand how to find it.

There's a time and place for... everything. Take a breath and think before you act.

There is too much... of everything. If you want to be different, you have to find a way of being special. Think laterally

In the end... the main thing is that you had a good day, every day.

My legacy... is running a business from the heart, not for the wallet.

PETER DUNDAS
Fashion Designer—Emilio Pucci

When I wake up... I answer correspondence and try to put on paper any ideas that came to me during the night. I think my thoughts unblock and dance when I'm half awake.

Before I go to bed... I try to be with someone I love or think of someone I love. A day should always end with a smile. Never with an argument.

A well-dressed man/woman... always has stylish shoes. Bad shoes can betray and destroy any look.

Women should always... have a perfect pedicure. It says everything about the rest.

Men should never... let their fingernails grow long. Again it speak volumes about the rest... haha by now it should be apparent that I come from a family of doctors!

The best thing that's been said about me... is that I have a kind heart. Now if this is always true is another matter.

The biggest misconception about me... is that I spend my time attending parties. I love having fun, but the biggest source of passion and amusement for me is my work. I am a Sagittarius. I do everything in bucketfuls.

If I weren't doing what I'm doing today... I would probably be a plastic surgeon. Somewhere there is a connection in all of this.

My legacy... My legacy? Hopefully living my life to its fullest and being the best I could possibly be.

A great idea... multiplies itself and takes on its own life almost indefinitely.

Botox is... seemingly responsible for making a lot of people look very strange in their faces. Beware!

My mother... died when I was four, but she is probably my biggest influence ever both in life and in my craft.

The soundtrack of my life... is "I'm Free" by The Who.

The future... is bright! Tomorrow's world is such an exciting place.

Happiness... is for me a silly concept. I believe in passion and satisfaction, which are much more obtainable and just as rewarding.

There's a time and place for... facing the facts, but it is also important to dream.

There is too much... focus on personal image. Everyone has become a brand.

In the end... all that matters is to have love and been loved. I am so lucky!

Happiness... is for me a silly concept. I believe in passion and satisfaction, which are much more obtainable and just as rewarding.

PETER SOM
Fashion Designer

When I wake up . . . I open my eyes.
Before I go to bed . . . I close my eyes.
A well-dressed woman . . . should never look like she tried too hard!
Women should always . . . follow Coco Chanel's advice—look in the mirror before going out and take one thing off.
Men should never . . . try to copy Johnny Depp's style. You won't succeed.
The best thing that's been said about me . . . is that I know what I'm doing.
The biggest misconception about me . . . is that I know what I'm doing.

If I weren't doing what I'm doing today . . . I'd be a baker.
My legacy . . . is yet to be told.
A great idea . . . is always welcome.
Botox is . . . a choice.
My mother . . . gives great advice!
The soundtrack of my life . . . would be a top seller on iTunes.
The future . . . is ahead of us!
Happiness . . . is being at the beach.
There's a time and place for . . . everything.
There is too much . . . of everything.
In the end . . . it's important to have fun.

The soundtrack of my life . . . would be a top seller on iTunes.

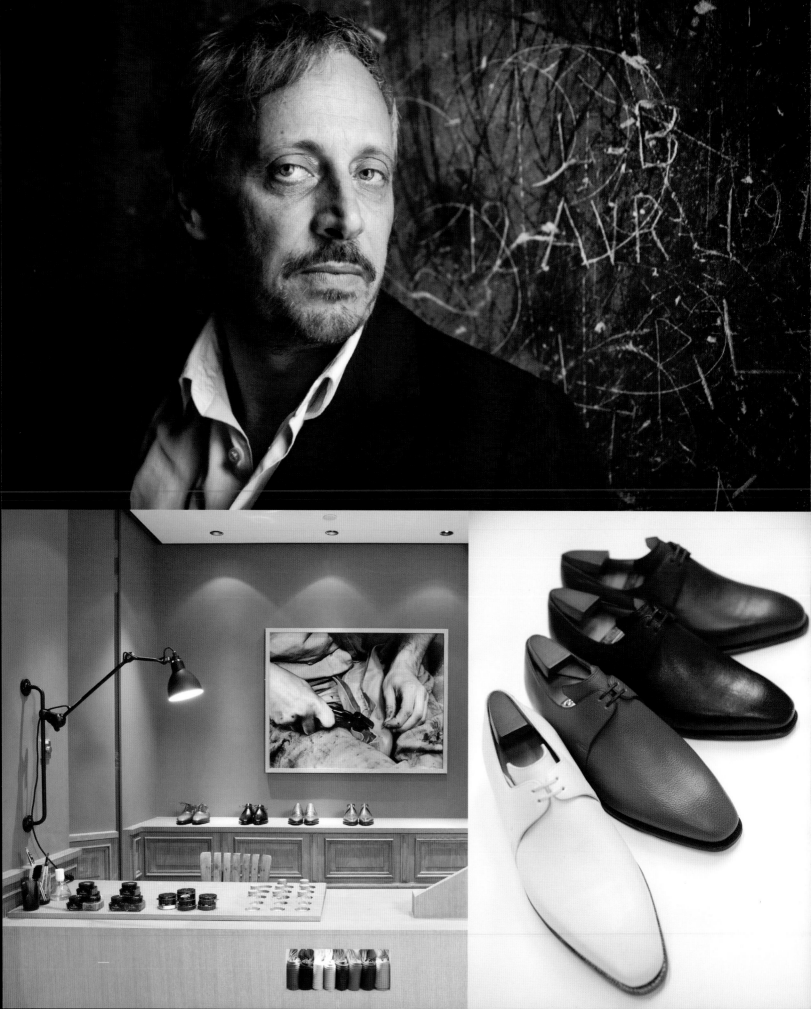

PIERRE CORTHAY
Shoe Designer

When I wake up... first of all a cup of green tea.

Before I go to bed... I take a look at different fashion and music blogs.

A well-dressed man... is a good balance between classical and unconventional pieces, the color of the shoes, for example...

Women should always... be natural. No surgery, no Botox.

Men should never... wear white socks.

The best thing that's been said about me... is that I'm a good colorist.

The biggest misconception about me... I don't make fashion; my goal is to create the most long-lasting, long-life products.

If I weren't doing what I'm doing today... I would certainly be a painter or a guitarist.

My legacy... is my children.

A great idea... firstly an idea is an idea, you have to wait to be sure that it is a good idea; time is your best friend.

Botox is... hmmm...

My mother... A great actress! Second only to my wife.

The soundtrack of my life... "You Must Believe in Spring," by Bill Evans.

The future... the present is the most important.

Happiness... to look to my last son, Elvis.

There's a time and place for... painting. Often, after dinner, I take time to work on art pieces.

There is too much... fake attitude.

In the end... be sure I was always at the right place.

If I weren't doing what I'm doing today... I would certainly be a painter or a guitarist.

POLLY APFELBAUM
Artist

When I wake up ... I look for coffee.
Before I go to bed ... I turn on the radio.
A well-dressed man ... needs good shoes.
Women should always ... wear good shoes.
Men should never ... not cook.
The best thing that's been said about me ...
"Do you smoke pot when you work?"
**The biggest misconception about
me** ... that I'm nice.
If I weren't doing what I'm doing today ... I
would work at the Post Office. I love mail.
My legacy ... no idea.

A great idea ... my Color Revolts.
Botox is ... not for me.
My mother ... is wonderful. And she has the
best eye of anybody I've ever met.
The soundtrack of my life ... Nirvana.
The future ... desperate optimism.
Happiness ... is being able to afford to do
what you want and enjoying it.
There's a time and place for ... time out.
There is too much ... complaining.
In the end ... a good night's sleep and nice
dreams.

The best thing that's been said about me ... "Do you smoke
pot when you work?"

RACHEL ROY
Fashion Designer

When I wake up... I read Deepak Chopra's tweets.

Before I go to bed... I kiss my kids.

A well-dressed woman... illuminates.

Women should always... sleep naked.

The best thing that's been said about me... she is loyal, funny, fun, and honest.

If I weren't doing what I'm doing today... I would find a new way to create the best quality of life for myself and others.

My legacy... is to empower women through employment.

A great idea... pen, paper, books.

Botox is... foreign.

My mother... is honorable, patient, and kind.

The soundtrack of my life... plays passionate, provocative, soulful, joyous music.

The future... is up to me.

Happiness... is within us all the time.

There's a time and place for... work.

There is too much... hurt.

In the end... the people I love and who love me will travel to the next realm with me.

In the end... the people I love and who love me will travel to the next realm with me.

RAFE TOTENGCO
Bag Designer

When I wake up... I turn on the news, check my emails and various social networking sites, and then have breakfast.

Before I go to bed... I usually flip through magazines and sketch on my notebook or iPad. Sketching is one of my favorite things to do to unwind.

A well-dressed woman... should be comfortable and confident with her personal sense of style.

Women should always... smile.

Men should never... talk about money in public.

The best thing that's been said about me... is that I make people happy.

The biggest misconception about me... is that I'm a serious person. I love to laugh until it hurts.

If I weren't doing what I'm doing today... I would be teaching kids how to draw. Creativity should be encouraged at an early age.

My legacy... if there should be one, is that I hope I made a lot of people happy with my work and with my friendship.

A great idea... should be realized as soon as possible especially if it improves the lives of others.

Botox is... a personal choice but it's not for me. I like seeing the lines and expressions on people's faces. Growing old gracefully is a beautiful thing.

My mother... is my hero. She showed me by example how I can live my life with integrity, compassion, honesty, and curiosity.

The soundtrack of my life... should be a mash-up between Adele and Sergio Mendes and produced by Mark Ronson, at least for this season.

The future... depends on what decisions I make today.

Happiness... is a day on the beach with my family in St. John.

There's a time and place for... work and play.

There is too much... social networking these days. I'm as guilty as everybody else. If there's an app for it, I probably have it. Once in a while I surprise friends and make an actual phone call.

In the end... I hope I get to check off everything on my list of things to do and places to see. It's long list so it will take a while but I'm enjoying the journey.

In the end... I hope I get to check off everything on my list of things to do and places to see. It's long list so it will take a while but I'm enjoying the journey.

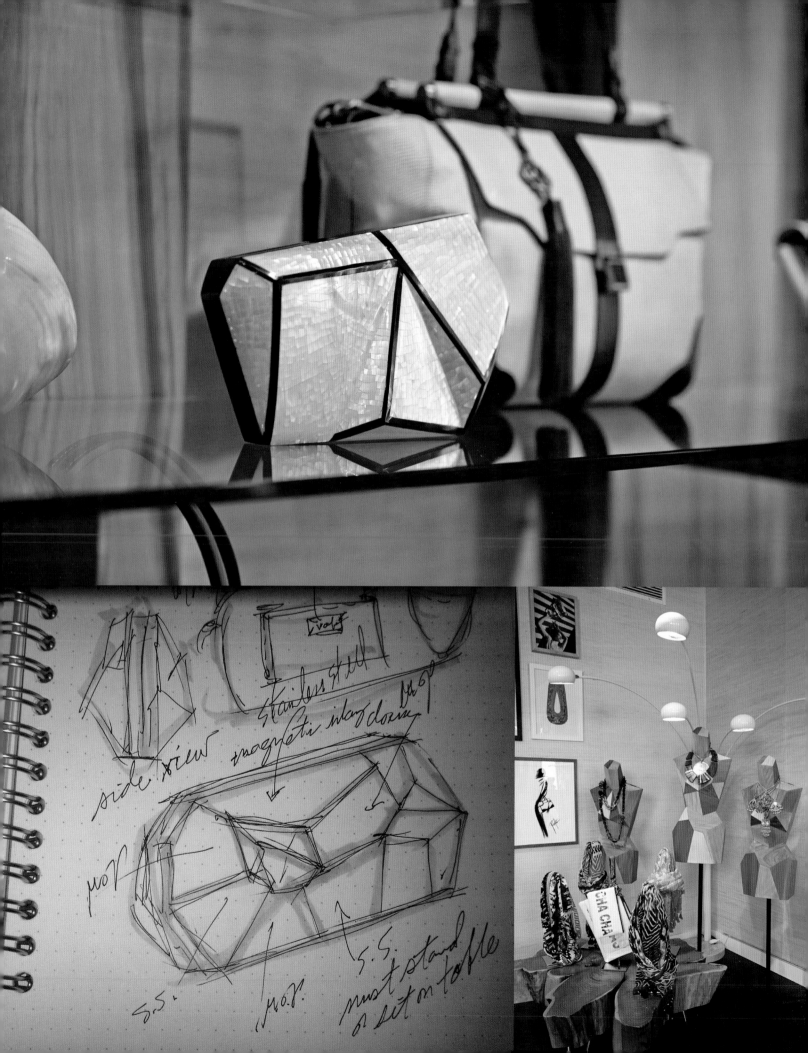

RICHARD PHIBBS
Photographer

When I wake up... I figure out what country, state, city, or village I am in.
Before I go to bed... I take my dog out.
A well-dressed man/woman... never wears fur.
Women should always... get paid the same as men.
Men should never... shave their chests.
The best thing that's been said about me... is that I am kind.
The biggest misconception about me... is that I am American.
If I weren't doing what I'm doing today... I would run an animal sanctuary.
My legacy... will be, I hope, images that inspire and cause a social change.

A great idea... would be for everyone to be kind to animals.
Botox is... fine for those who want it.
My mother... taught me to be kind to strangers and introduced me to the work of Michaelangelo and Picasso.
The soundtrack of my life... Nam Myho Renge Kyo.
The future... is bright.
Happiness... is the goal.
There's a time and place for... sorrow.
There is too much... suffering.
In the end... it's about one's dignity.

When I wake up... I figure out what country, state, city, or village I am in.

REED KRAKOFF
Fashion Designer

When I wake up... I'm happy to see my wife.

Before I go to bed... depends on the night of the week.

A well-dressed man... isn't noticed for what he is wearing.

Women should always... feel strong and confident and above all, feel like themselves.

Men should never... try too hard.

The best thing that's been said about me... is that I won't fail.

The biggest misconception about me... is that I'm too serious.

If I weren't doing what I'm doing today... I'd be a photographer or landscape architect.

My legacy... is to teach my four children to believe in themselves.

A great idea... is never enough.

Botox is... not for me.

My mother... asked me, when I first started out in fashion, why I would ever want to be a designer.

The soundtrack of my life... is constantly changing.

The future... is what you want it to be.

Happiness... is not having to think about whether you are happy or not.

There's a time and place for... everything.

There is too much... I want to do.

In the end... always trust yourself.

My legacy... is to teach my four children to believe in themselves.

RUPERT SANDERSON
Shoe Designer

When I wake up... I check the pistol is still under the pillow.

Before I go to bed... I check my children are in their respective beds.

A well-dressed woman... exudes self-confidence.

Women should always... that's not for any right thinking man to say.

Men should never... laugh during the sad bits.

The best thing that's been said about me... I'm a great tennis player.

The biggest misconception about me... I'm not really a very good tennis player.

If I weren't doing what I'm doing today... I'd have to ask someone to do it for me tomorrow.

My legacy... too soon to tell.

A great idea... hits you like a frying pan in the face.

Botox is... a horrible sounding word I don't think I've ever used.

My mother... thinks I work in a bank.

The soundtrack of my life... English birdsong mashed up with some big brass funk.

The future... looks shoe-shaped.

Happiness... is where I am this second.

There's a time and place for... Morris dancing.

There is too much... of the stuff that we don't really need.

In the end... you've got to make sure it was all worth it.

The future...
looks
shoe-shaped.

SIMON SPURR
Fashion Designer

When I wake up... I walk the dog.

Before I go to bed... I have a cup of tea.

A well-dressed man... should have manners to complement the way he is dressed.

Women should always... love their man (Jim Morrison).

Men should never... cheat on their women.

The best thing that's been said about me... is that I'm getting visually younger each year.

The biggest misconception about me... is that I'm American. I'm British.

If I weren't doing what I'm doing today... I would be doing it tomorrow.

My legacy... will be determined by how well I raise my children.

A great idea... is not always the biggest idea.

Botox is... simply wrong.

My mother... loves me, my brother, and my father dearly.

The soundtrack of my life... hasn't been written yet.

The future... is uncertain, but it is what you make of it.

Happiness... focusing on what you have and not what you don't have.

There's a time and place for... laughing. Any time and any place.

There is too much... reality TV.

In the end... I feel secure, loved and am lucky to have the most amazing friends in the world.

A well-dressed man... should have manners to complement the way he is dressed.

SOPHIE THEALLET
Fashion Designer

When I wake up... I need a coffee.

Before I go to bed... I have a glass of wine.

A well-dressed woman... is confident and free-minded.

Women should always... be dangerous.

Men should never... wear a hairpiece.

The best thing that's been said about me... is that I don't leave anyone indifferent.

The biggest misconception about me... I have no idea.

If I weren't doing what I'm doing today... I would be painting ceramic plates.

My legacy... is to keep couture tradition alive.

A great idea... I am always waiting for it.

Botox is... helpful when it's well done.

My mother... is a force of nature.

The soundtrack of my life... rock and roll.

The future... is now.

Happiness... is overrated.

There's a time and place for... fashion.

There is too much... mediocrity.

In the end... all worries were in vain.

In the end... all worries were in vain.

STACEY BENDET
Fashion Designer

When I wake up... I do yoga. This is usually by 5 a.m.

Before I go to bed... hmmm, this is a tough question for someone who does not sleep a lot, but pink champagne and lacy lingerie sounds like a good start.

A well-dressed woman... always makes me smile!

Women should always... get their sparkle on.

Men should never... wear belts with big logos on them.

The best thing that's been said about me... is that I am a great mother and wife and a hard worker. The rest to me is irrelevant.

The biggest misconception about me... is when my husband says I am a diva. Actually I just travel with eighteen suitcases and at least two hat boxes because I like to play dress up! I mean...

If I weren't doing what I'm doing today... oh, I don't know. I would like to say I would be a rock star, but that would require having some musical talent.

My legacy... the perfect pant? I hope so one day!

A great idea... I think there are great ideas every day the key is to be able to make those ideas come to life.

Botox is... okay for people who aren't needle-phobic?

My mother... is the most beautiful mother and the most incredible grandmother, and I hope my children love me as much as I love her! (Dear Sister, I am totally the favorite daughter as soon as mom reads this!)

The soundtrack of my life... "I Want Candy." Eloise, my daughter, would say that same.

The future... is whatever you want it to be. Mine definitely includes high heels and sparkly dresses.

Happiness... is loving the people around you and knowing they love you. But a new pair of shoes never hurt either.

There's a time and place for... sweatpants. Or at least that is what I keep telling my husband!

There is too much... too much almost always means just enough!!

In the end... we all have our imaginations...

The future... is whatever you want it to be. Mine definitely includes high heels and sparkly dresses.

SUZANNE SHARP
Co-founder—The Rug Company

When I wake up...I usually go back to sleep.

Before I go to bed...I kiss my husband goodnight.

A well-dressed man/woman...writes his or her own rules.

Women should always...have clean hair.

Men should never...wear white socks.

The best thing that's been said about me... "she's great with color."

The biggest misconception about me...I have no idea!

If I weren't doing what I'm doing today... I'd be a photographer.

My legacy...four amazing children.

A great idea...is born from the tiniest detail.

Botox is...not for the faint hearted.

My mother...was beautiful and feisty.

The soundtrack of my life..."Dance Me to the End of Love" by Lena Mandotter from the *Songs of Leonard Cohen*.

The future...is digital.

Happiness...is a beach that stretches out of sight, an ocean to ourselves.

There's a time and place for...closing your eyes.

There is too much...backtracking.

In the end...the best things in life just happened.

Happiness...is a beach that stretches out of sight, an ocean to ourselves.

In the end...
my ashes in a
cocktail glass.

TADASHI SHOJI
Fashion Designer

When I wake up... I check my blood pressure.

Before I go to bed... I turn off the light.

A well-dressed woman... doesn't advertise a certain label.

Women should always... be in love.

Men should never... be without love.

The best thing that's been said about me... is that I have defeated jet lag.

The biggest misconception about me... is that I take myself seriously.

If I weren't doing what I'm doing today... I'd be dead.

My legacy... is making women feel good.

A great idea... is in my dream, but vanished when I woke up.

Botox is... vain.

My mother... went to a better place a long time ago.

The soundtrack of my life... is silence.

The future... is deciding which country is best for my retirement.

Happiness... is with my significant person.

There's a time and place for... living in the moment, which should be always!

There is too much... sickness of close friends.

In the end... my ashes in a cocktail glass.

THOM FILICIA
Interior Designer

When I wake up... I have a panic attack because I'm usually fifteen minutes behind schedule.

Before I go to bed... I look up to heaven and I think to myself, "If I die before I wake, I'm going to be so pissed off because my apartment is a wreck!"

A well-dressed man/woman... should never be too well-dressed and a well-dressed woman should be effortless.

Women should always... take off one accessory before they leave the house.

Men should never... overly man-scape.

The best thing that's been said about me... is that I've inspired them through design and humor and that they appreciate my salt-of-the-earth sensibility.

The biggest misconception about me... is that television design is my primary platform, which couldn't be further from the truth, as I have had an established design firm in New York City for many years.

If I weren't doing what I'm doing today... I'd be a ski instructor by day and a spokesperson for Ketel One Vodka by night.

My legacy... is encouraging the democracy of design.

A great idea... airplanes. I still don't understand how they work.

Botox is... moronic.

My mother... always said to tell a dirty joke and you'll quickly figure out who's up for a good time and who's not.

The soundtrack of my life... *The Big Chill.*

The future... is optimistic, exciting, and happening right now!

Happiness... is sitting on my boat with a fabulous glass of wine, great friends, and a couple of dogs wearing life preservers.

There's a time and place for... most things I say, but not most things I think.

There is too much... square footage in new bathrooms.

In the end... you should be judged for how much fun you had and for how many people you shared it with.

My mother... always said to tell a dirty joke and you'll quickly figure out who's up for a good time and who's not.

TIMOTHY CORRIGAN
Interior Designer

When I wake up... I, without fail, wish that I could sleep a little longer.

Before I go to bed... I recount all of the things for which I am grateful...it beats counting sheep every time!

A well-dressed man... is someone who knows what does and, perhaps more importantly, does not, look good on him.

Women should always... have been a part of the world of business as they bring wonderful values to the workplace.

Men should never... forget that showing emotions can be a sign of strength.

The best thing that's been said about me... is overstated by at least ten-fold.

The biggest misconception about me... is that I am a gourmand of any kind. My nieces and nephews call me "Junkfood Man."

If I weren't doing what I'm doing today... I would be a landscape architect; as each year passes I yearn to be in nature more and more.

My legacy... I would like people to come to understand the positive connection between one's surroundings and their well-being.

A great idea... is one that you don't regret the next morning.

Botox is... great if it makes you feel one ounce better about yourself.

My mother... was beloved by more people than I could have ever imagined.

The soundtrack of my life... Rodrigo's "Concerto to Arunjez." I try to live my life with that level of passion and depth. It is a soaring piece of music that never fails to move me.

The future... is fine, but today is what really matters.

Happiness... for me is continuing to explore and learn new things.

There's a time and place for... cell phones and it is not at a dinner table. It drives me mad when people start texting or reading email at a table of friends or family.

There is too much... electronic communication and not enough human connection.

In the end... all that matters is the love that we have shared with others.

Before I go to bed... I recount all of the things for which I am grateful...it beats counting sheep every time!

TOMMY HILFIGER
Fashion Designer

When I wake up... I check messages on my iPhone.

Before I go to bed... I kiss my wife, Dee, good night.

A well-dressed man... always has a tailored navy blue blazer in his closet.

Women should always... dress to express themselves.

Men should never... stray too far from the classics: crisp button down, tailored jacket, slim fit chinos.

The best thing that's been said about me... is that my clothing is iconic.

If I weren't doing what I'm doing today... I would be playing guitar in a rock band.

My legacy... is in the non-profit programs we support through Tommy Cares.

A great idea... reinterprets classics with a new and refreshing twist.

My mother... is one of the strongest women I know.

The soundtrack of my life... is The Rolling Stones.

The future... always holds exciting new possibilities and opportunities.

Happiness... is being inspired by your passions.

There's always a time and place for... rock 'n' roll.

There is too much... suffering in the world. We work to make a change with the programs and initiatives we support through Tommy Cares.

In the end... family and friends are what really matter in life.

The soundtrack of my life…
is The Rolling Stones.

VICENTE WOLF
Interior Designer

When I wake up... the first thing I do is jump rope and do sit-ups, quickly followed by spraying all my orchids and plants for their morning bath.
Before I go to bed... I read the book of the moment. Right now, it's *That Woman* about Wallis Simpson, Duchess of Windsor.
A well-dressed man/woman... should always look fresh like they've just come out of the shower with clothing that never looks overly-thought out and should never be overly-dressed.
Women should always... smell wonderful.
Men should never... wear too much jewelry.
The best thing that's been said about me... is that I am spiritual and like to give back to society with the same generosity that I was shown throughout my life.
The biggest misconception about me... is that most people think that I'm unapproachable and that their budget is never big enough for me. Wrong in both cases.
If I weren't doing what I'm doing today... I would be one of the many people who fell off by the wayside as I was fired from every job that I ever had. When I first started working, I was nervous about where I'd fit in. I tried acting, but I have no memory. I tried merchandising, but I didn't like the creative constraints. I tried advertising—in the processing end—but I'm dyslexic and it didn't work out. I was in modeling but I could visualize better shots than the photographer was taking and I wasn't the all-American type. If the interior design door had not opened, who knows?
My legacy... I want to be seen not as a one-dimensional individual, but as someone who was never restrained by boundaries. I want people to think that I gave back to society and didn't just take. Oh yes, and that I was creative.
A great idea... should always be acted upon, because if it's floating out there someone else will pick it up and you will kick yourself for not acting on it.
Botox is... great for migraines and good for the ego.
My mother... was a Capricorn like I am. Determined, a steamroller, and highly-inventive and entrepreneurial.
The soundtrack of my life... has a great Latin beat.
The future... is the future but I can only deal with the here and now.
Happiness... is from within, and if you chase it outside it's never going to work.
There's a time and place for... work, but life is to be lived. We're not here just to work.
There is too much... sense of entitlement in our society.
In the end... it goes back to the beginning.

Botox is . . . great for migraines and good for the ego.

YIGAL AZROUEL
Fashion Designer

When I wake up... I go for a run on the West Side Highway.

Before I go to bed... I like to relax and do a little reading on my iPad.

A well-dressed woman... never looks like she's trying too hard.

Women should always... be confident and not worry about what other people think.

Men should never... stop searching for the perfect fit of his clothing.

The best thing that's been said about me... is that I'm not an egoist.

The biggest misconception about me... is that I eat too much chocolate.

If I weren't doing what I'm doing today... I would be a professional surfer.

The soundtrack of my life... is always changing.

The future... is a conversation between luck and destiny.

Happiness... is the key to success.

There's a time and place for... fun and work.

There is too much... noise.

In the end... we will never know.

The future ... is a conversation between luck and destiny.

ACKNOWLEDGEMENTS

Thank you to Kristin Kulsavage, Skyhorse and everyone who made who made this book possible.

Thank you to my family and to the Bromberg family as well.

Thank you to everyone who have helped me through out my career as a fashion journalist and now as a designer and retailer.

Thank you to my dear friends: Wendy Puyat, Jackie and Marco Antonio, Peewee Reyes, Don Vytiaco, Ramon Padilla, Tina Leung, Sean Lee Davies, Manika Yujuico, Divia Harilela, Giselle Go, Alicia Sy, Joanna Valencia, Heather Clawson, Chandler Hudson Kenny, Albert Lo, Emily Leung, Jane Lee, Maybelline Te, Valentina and Ernesto Loffredo, Paul del Rosario, Luis Fernandez, Minelli Bautista, Marcus Teo, Mitja Bokun, Darren Ho, Sarah Rutson, Nicholas Koh, Michele Periquet, Fieroes Zeroual, and Michael Venzon.

Thank you to Fiona Kotur Marin for being a wonderful mentor. And thank you Nathan Turner for the friendship.

Thank you to my staff at Blue Carreon Home and everyone who comes to support the store.

Thank you to everyone who reads the column in The Huffington Post as well as those who read my posts for Forbes, my blog Style Intel as well as my work for various publications.

I am truly grateful.

PHOTO CREDITS